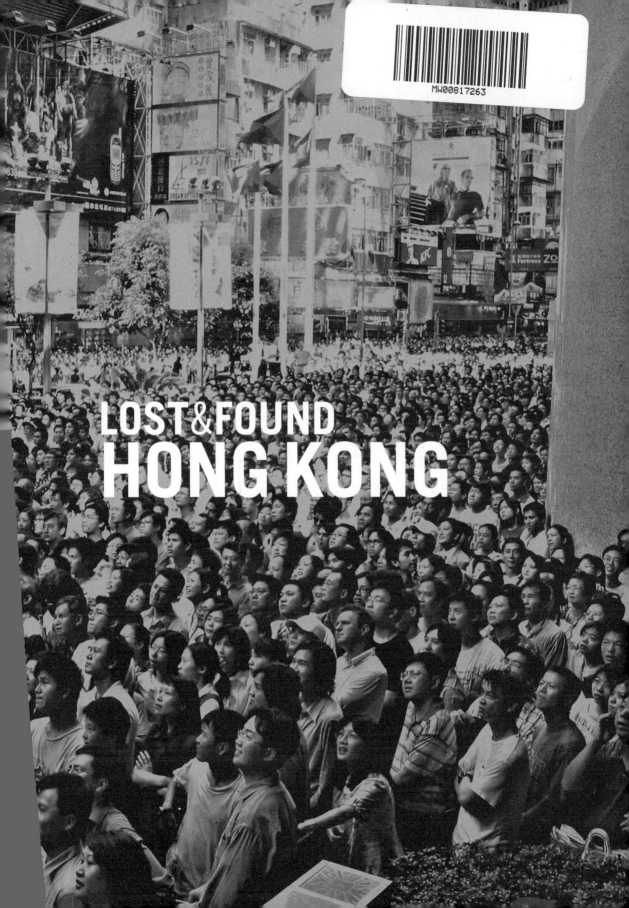

LOST&FOUND
HONG KONG

LOST&FOUND HONG KONG

Edited by Janet McKelpin
Photography by Hank Leung, Albert Wen, Blair Dunton,
Elizabeth Briel, and Li Sui Pong

Copyright ©2009 ThingsAsian Press

Credits and copyright notices for the individual photo essays
in this collection are given on page 274-285.

Art direction and design by Janet McKelpin
Editing assistance provided by Jeff Boyd, Chi-Ming Chien, and Janet Brown
Chinese translation by Michelle Lai Wong

For information regarding permissions, write to:
ThingsAsian Press
3230 Scott Street
San Francisco, California 94123 USA
www.thingsasianpress.com
Printed in Singapore

ISBN-13: 978-1-934159-17-0
ISBN-10: 1-934159-17-4

香港

When my husband confessed that of all the cities in the world, he would choose to live in Hong Kong, I was surprised. I have a slight bias toward the place, but I was born there. My husband's first reaction to this city was to retreat to a nearby alcove in an attempt to escape a Kowloon sidewalk filled with fast-moving, aggressive pedestrians pushing their way through rush hour. The sensory overload from a city that some might describe as dirty, smelly, and crowded initially overwhelmed this man who now, after several trips to Hong Kong, says he wants to live there.

My husband has discovered Hong Kong. I have rediscovered it, after moving away when I was a small child. We are both attracted to those sights, sounds, and smells that to us are uniquely Hong Kong, to its contrasts of chaotic and serene, noisiness and calm. In bustling Mong Kok, a hole-in-the-wall shop is

the unlikely setting for a peaceful meal. A can of coffee provides an instant oasis when savored in the middle of the busy crowd of shoppers in Tsim Sha Tsui.

Of course visiting a city and living there are very different experiences. My husband's affinity for Hong Kong and my recently resurrected fondness for my birthplace made us wonder what it is like to live here. This is the question that led us to **Lost&Found Hong Kong**.

We invited five people who have made this city their home to tell us why they live here and what they feel about it. As they opened their lives to us, they allowed us to wander with them through the streets they walk through every day, to meet the people in their world whom we otherwise would

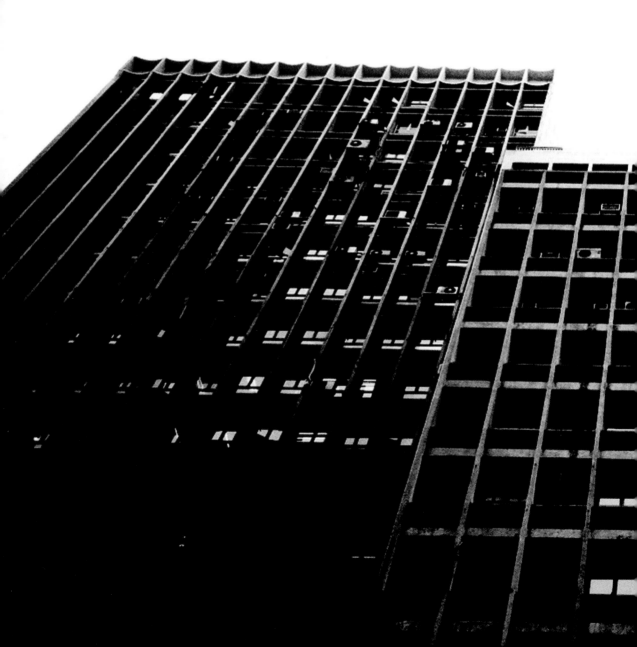

never encounter, to hang out with them in their special refuges, to observe the objects that only the inhabitants of a neighborhood are aware of. They let us get lost in their lives, let us catch a ride on their daily rhythms, in the mood and speed of their city. With them we were allowed to dive deeper into their Hong Kong lives and to glimpse the perspective of residents.

For some of the people who opened their city to us, Hong Kong is a temporary home. Others may set their roots here and never leave. They are very different with one thing in common. They all left a familiar spot to come to Hong Kong, to get lost and learn to find their way. What have they discovered and what have they yet to find in this city?

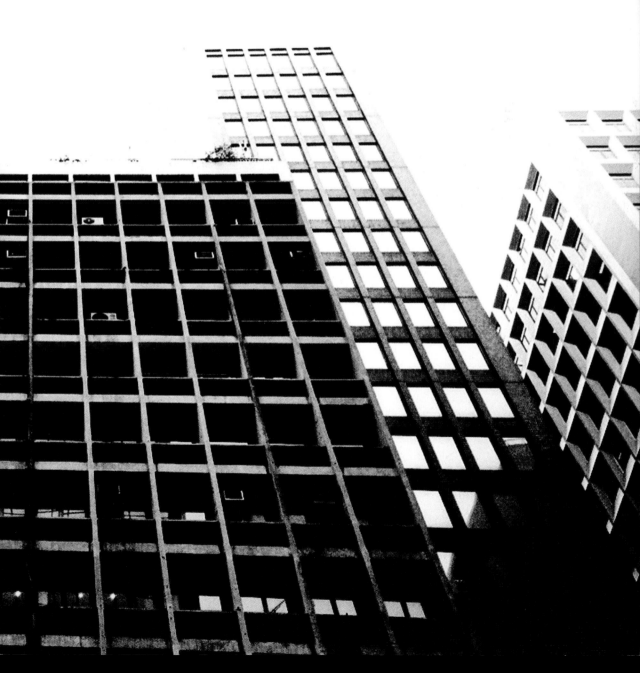

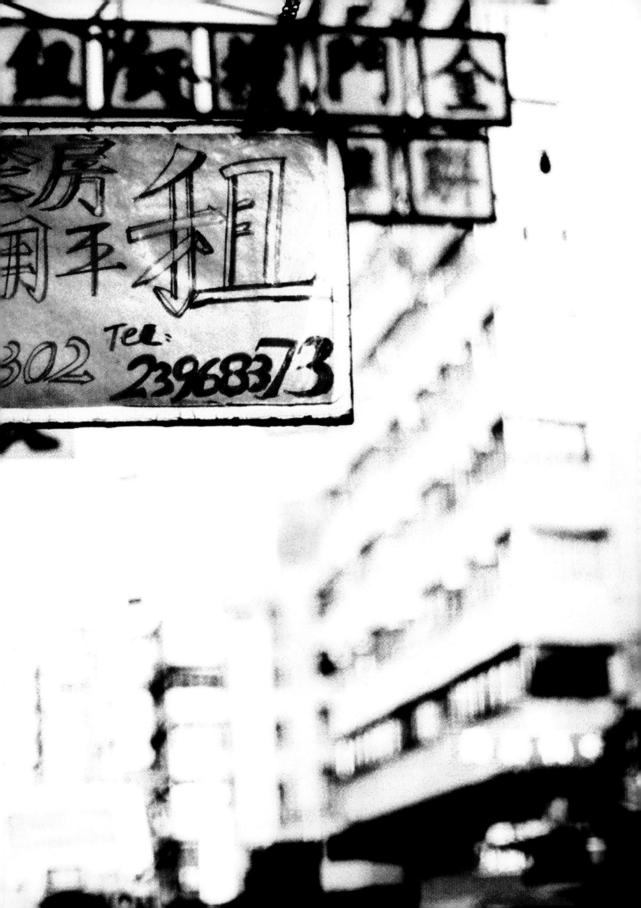

當外子對我坦承在世界各大都市中，他會選擇定居在香港的時候，我非常驚訝。我對香港的確有些偏愛，不過那是因為我出生在這裡。而外子對這個城市的第一個反應，是撤退到路邊的小涼亭去透一口氣，好逃避充斥於九龍人行道上，那羣在尖峰時刻中迅速移動、又推又擠、幾乎像帶著攻擊性的人潮。外子起初差一點被這個有些人形容為又擠、又髒、又臭的都市衝垮，多去香港幾次後，竟然說他要定居在這裡。

外子新發現了香港，我則從小就移民美國，最近幾次返港旅行之後，又再次發覺這個城市的魅力。屬於香港特有的影像、聲音、和味道，混亂與和平、吵雜與安靜的有趣反差，深深地吸引著我們。在喧囂的旺角，一家狹小的食鋪，出乎意外地可以讓人平靜地享用一頓餐點。置身在尖沙咀熙來攘往的購物人潮中，啜飲一瓶罐裝咖啡，立刻彷彿處在沙漠中的綠洲一般。這到底是些什麼樣的地方呢？讀者們可能從來沒有去過香港，完全沒有任何概念。

當然，短暫停留香港和長期定居大不相同。外子對香港的喜愛，和我對我的出生個地新復甦的鍾情，讓我們很想知道，定居在這個城市到底是一種什麼樣的感覺。為了追尋這個問題的解答，引導出了編纂 LOST&FOUND HONG KONG 的計畫。

我們特地邀請了五位以香港為家的居民，來向我們描述他們選擇定居這裡的理由，和我們分享他們對香港的感覺。在展示他們生活的同時，也允許我們跟隨他們的腳步，徘徊於他們每天走過的街道，遇見我們以往不可能有機會碰上的人，流連於他們經常駐足的地方，停下來觀察只有當地居民才會知曉的微妙事物。他們使我們為香港人的生活著迷、困惑，讓我們跟著他們的日常生活節奏，去體驗這個都市的心情和速度，追隨他們更深入地去探究他們的香港生活，稍微嘗試從當地居民的獨特角度，來認識這個城市。

對某些人而言，香港只是個臨時的家。就其他人來說，他們在這裡扎根，從來沒有離開過。他們既是完全不同的人，又有一點相似之處─在生命的某一刻，他們都離開了熟悉的地方來到香港，在這裡迷失，又不得不學著尋找出路。哪些是他們在這個都市中尋獲的？哪些是他們還未曾發現的呢？

CITY DWELLERS 香港
Hank Leung Hunghom 紅磡
Albert Wen Wanchai 灣仔
Blair Dunton SOHO 蘇豪
Elizabeth Briel Lamma Island 南丫島
Li Sui Pong Pok Fu Lam 薄扶林

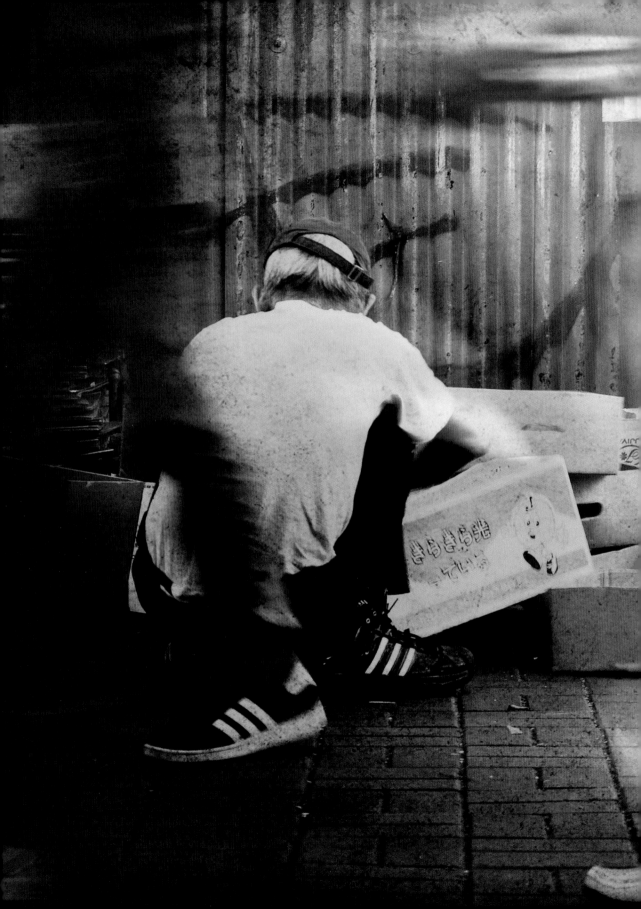

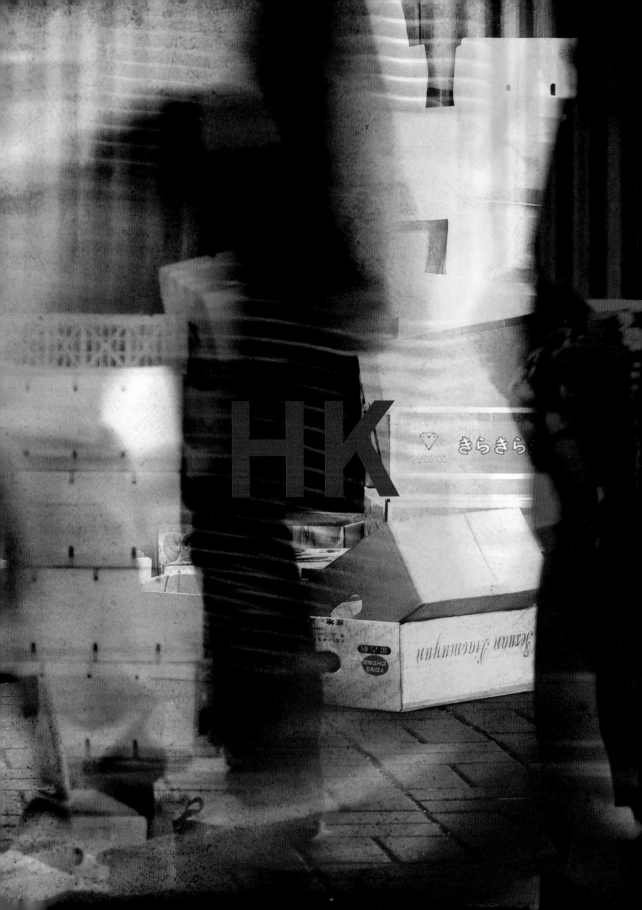

One Hong Kong: Neon nightlife, monuments to the gods of commerce scrape the sky. The other Hong Kong: everyday people in hulking apartment blocks, browsing butchers' stalls and taking care of the necessities of daily life.

一個香港是充滿燈紅酒綠、紙醉金迷的夜生活；到處林立高聳入雲的摩天大樓，彷彿遍地豎著商業神主牌的都會。另一個香港是尋常百姓聚居在櫛比鱗次的公寓、大廈裡，每天忙著在肉攤子上挑揀生鮮食品，料理瑣碎的日常生活。

Hánk Leung Hunghom 紅磡

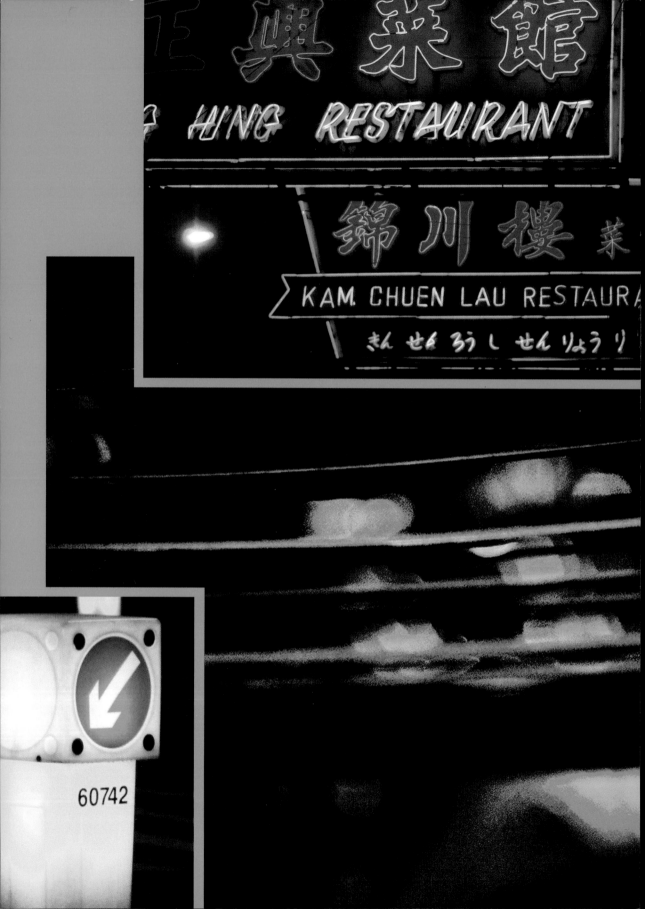

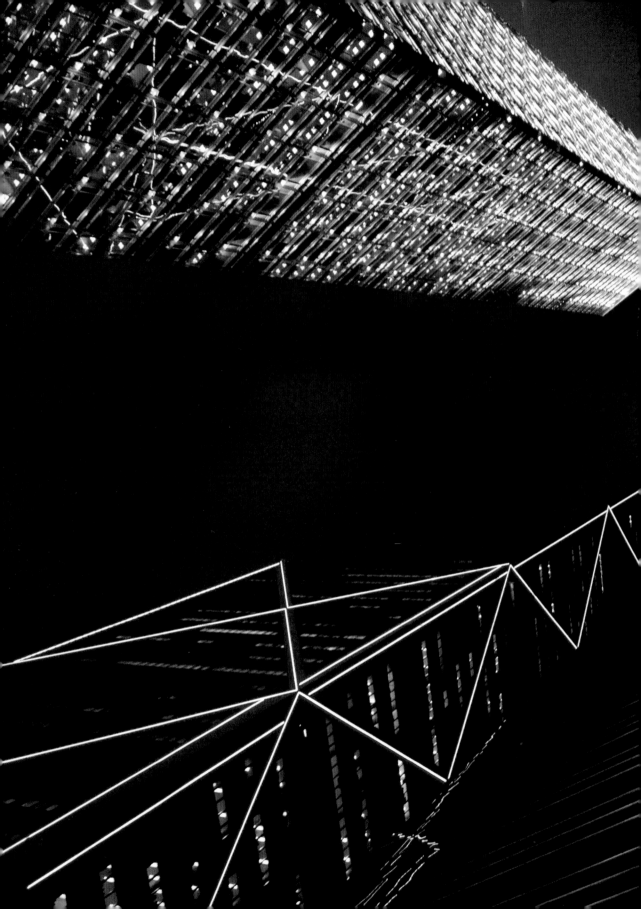

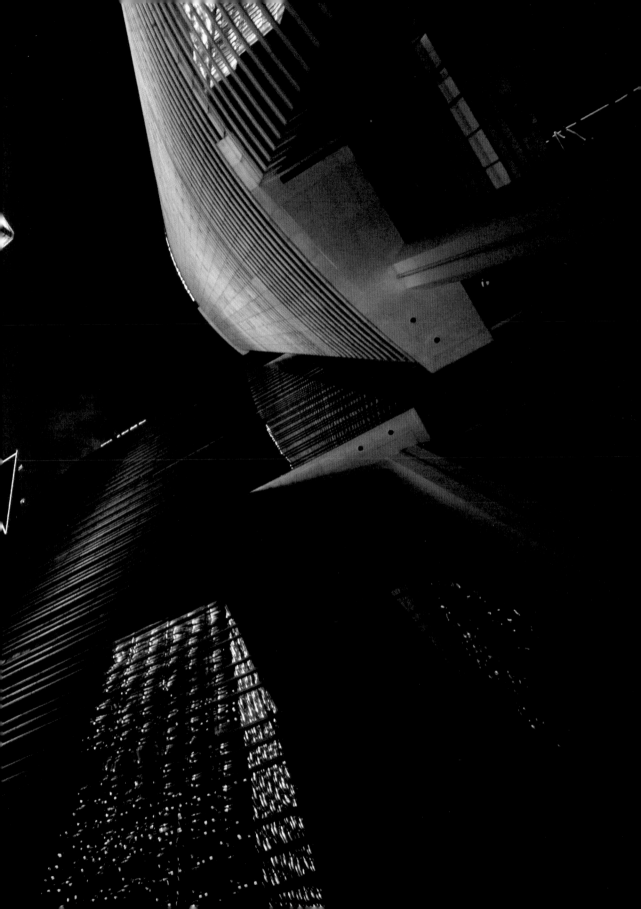

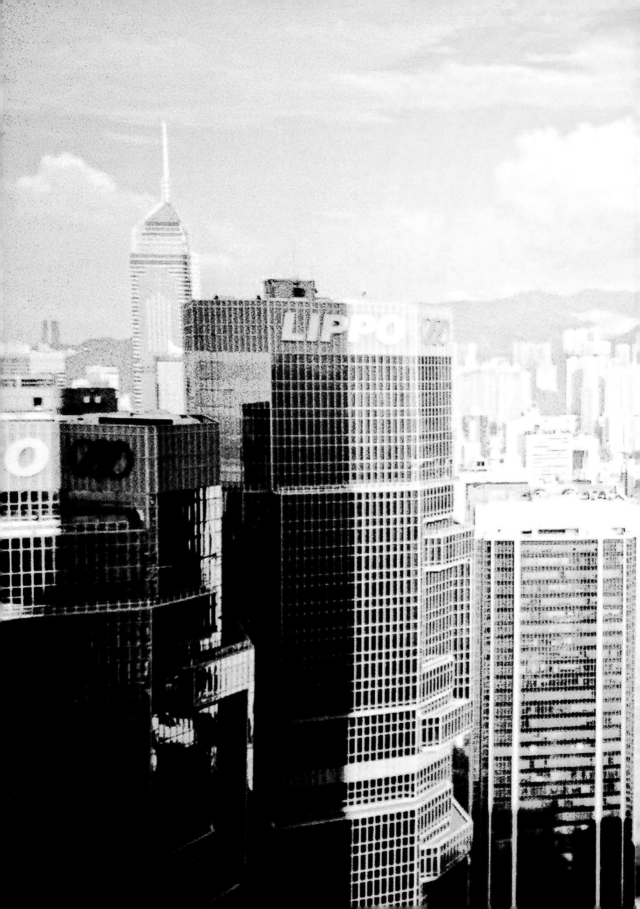

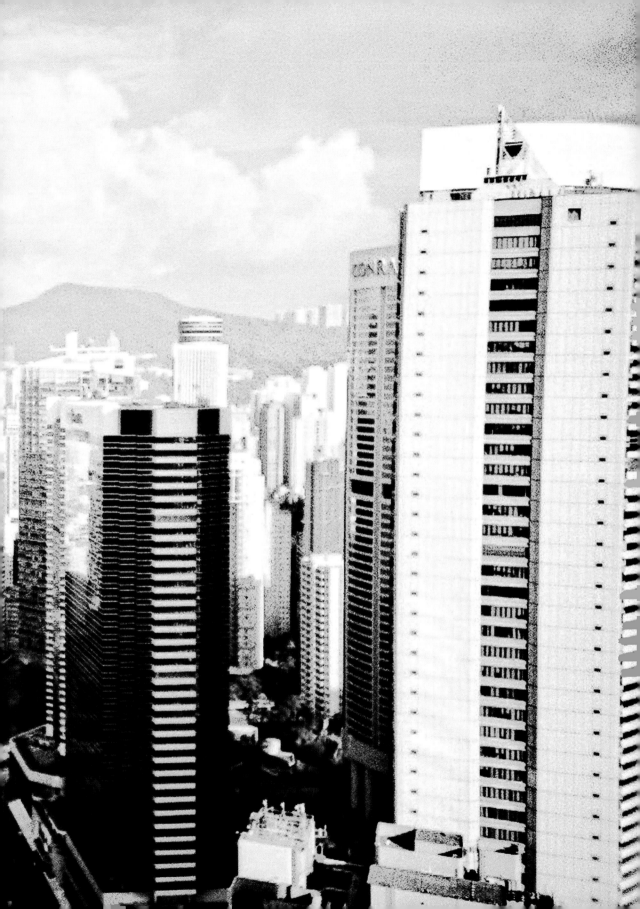

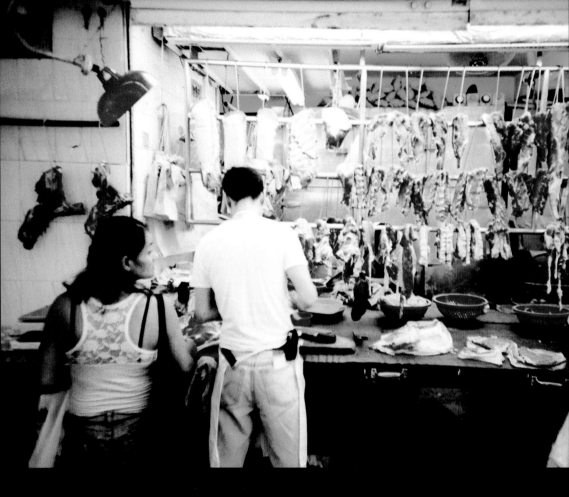

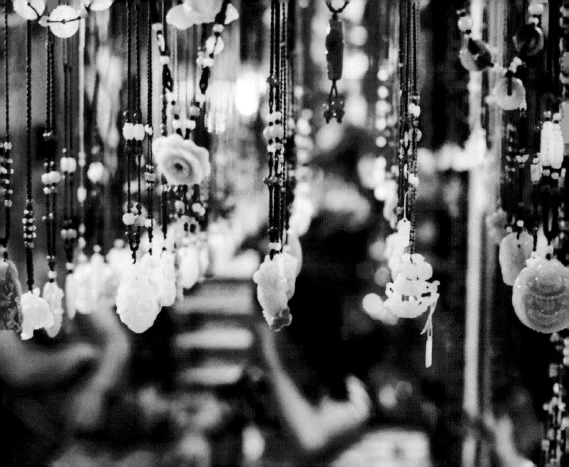

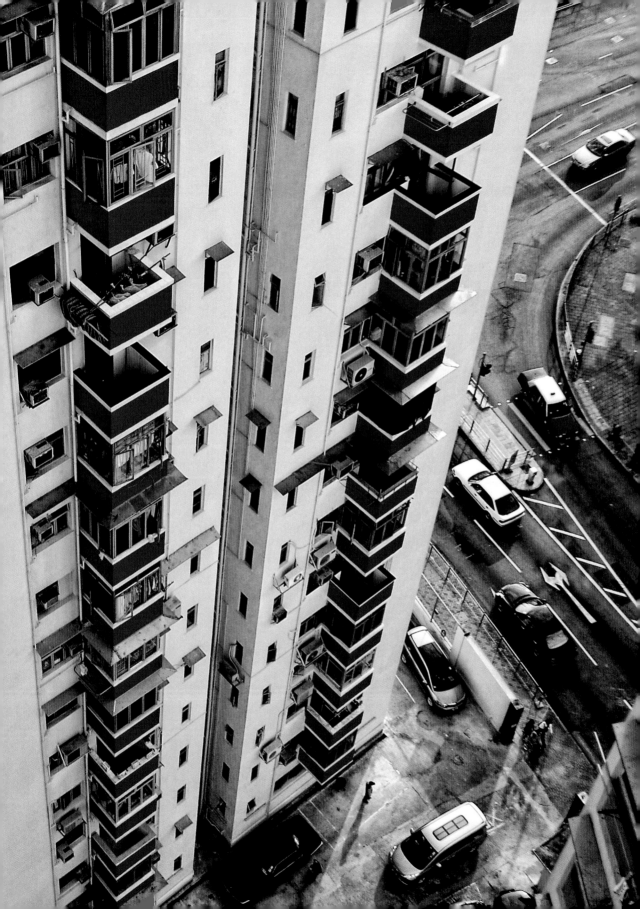

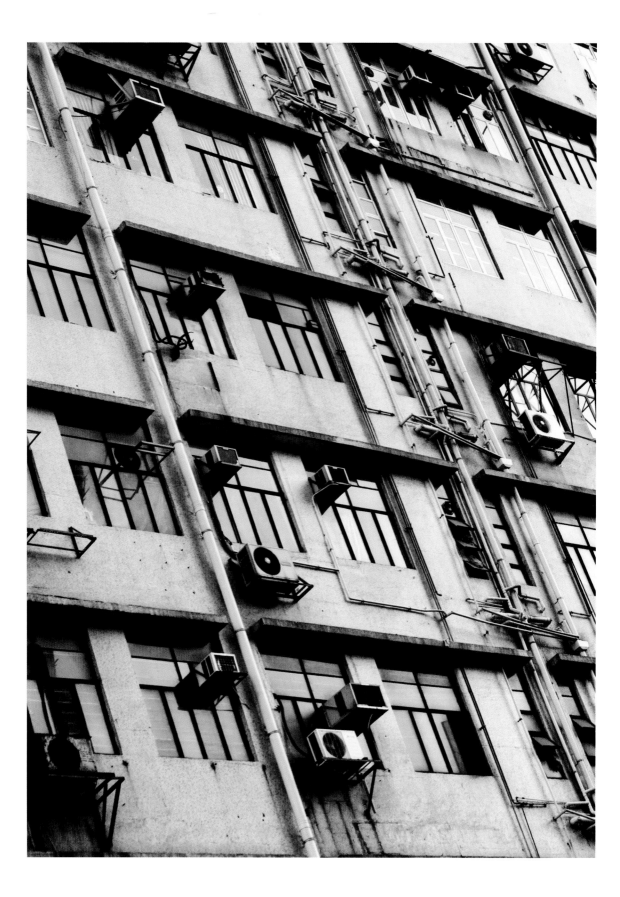

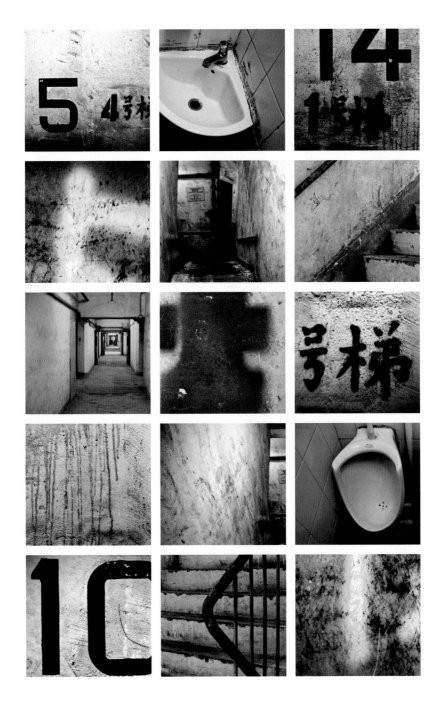

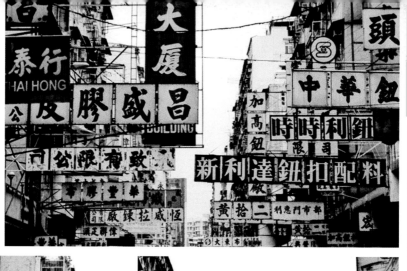
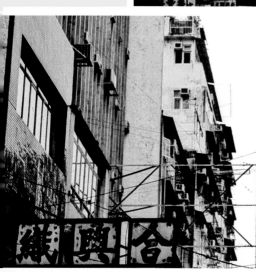
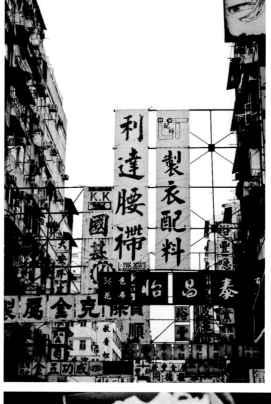
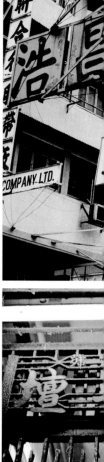
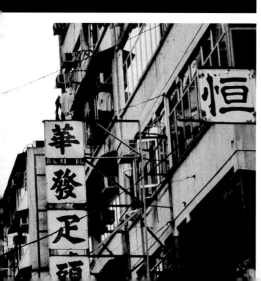

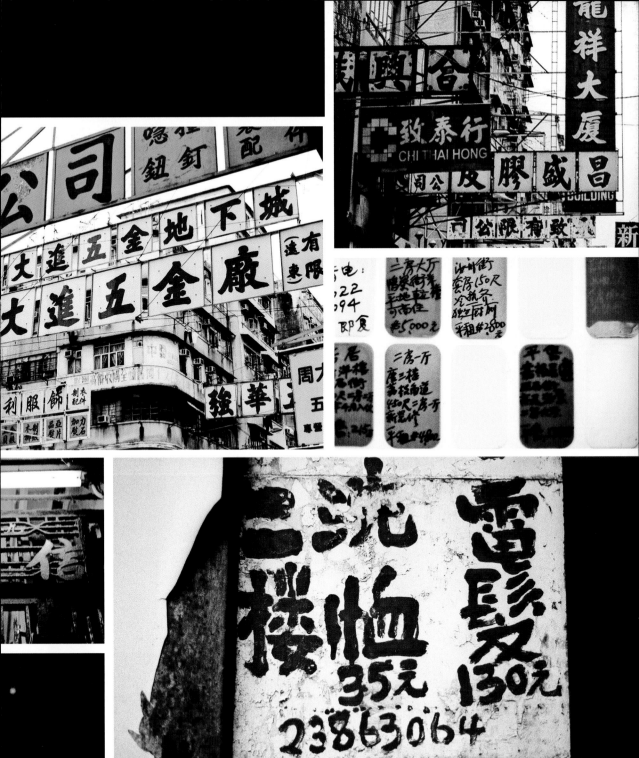

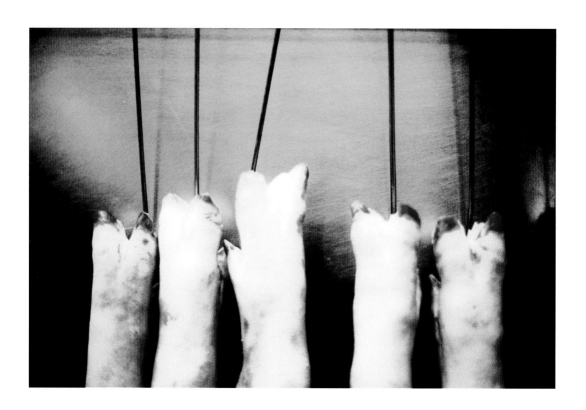

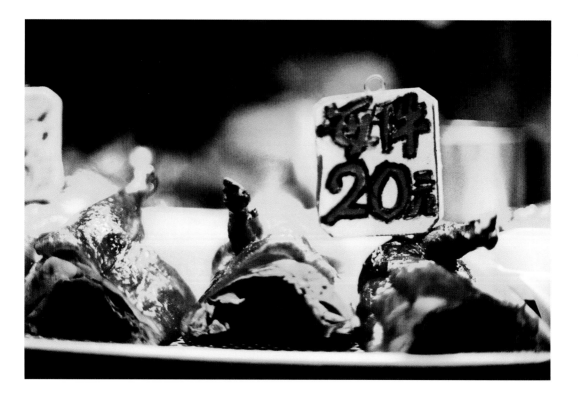

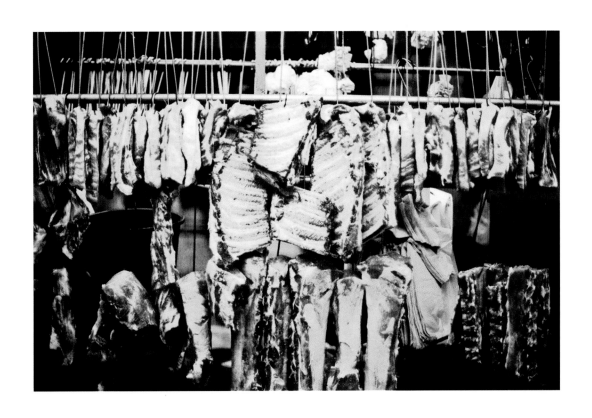

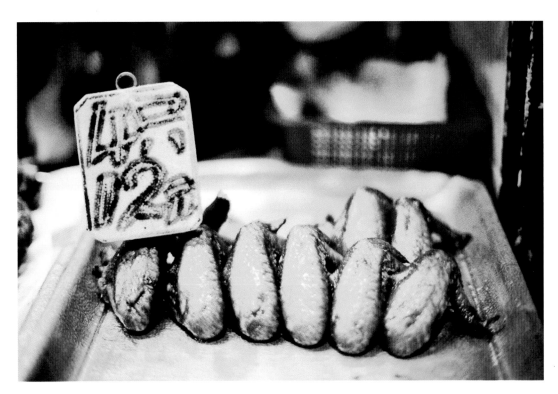

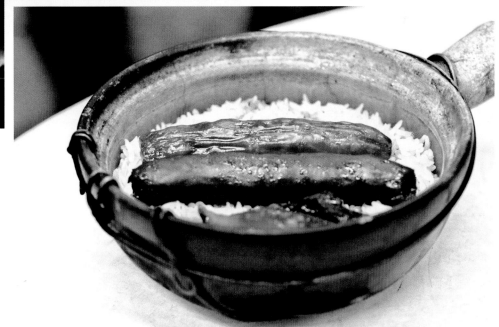

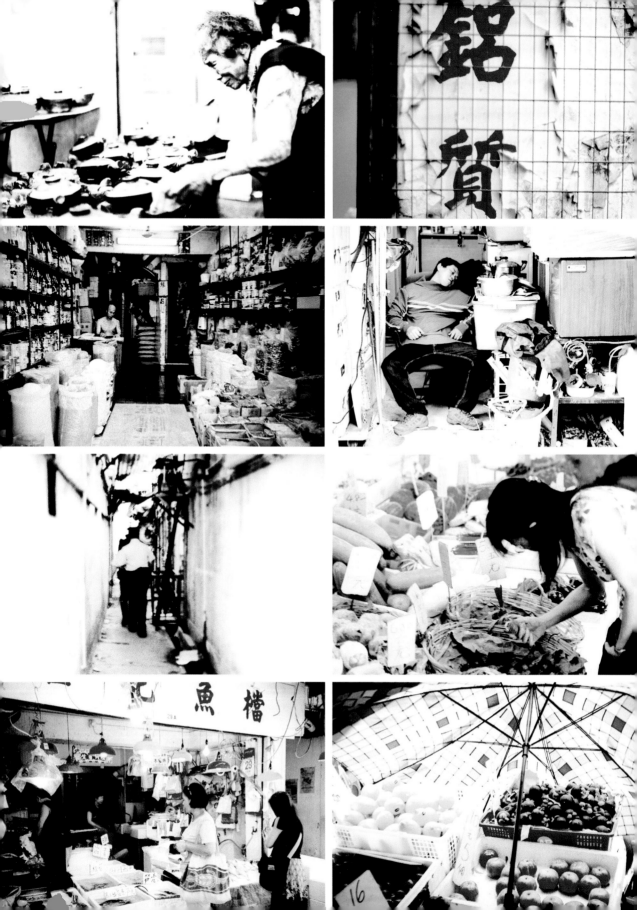

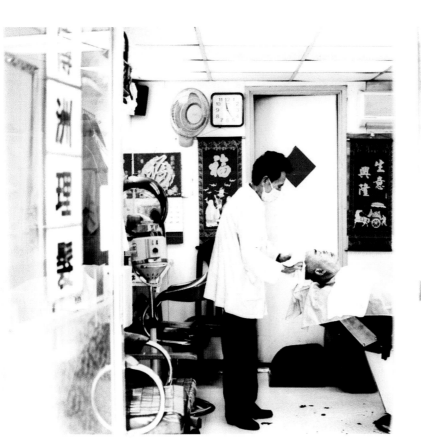

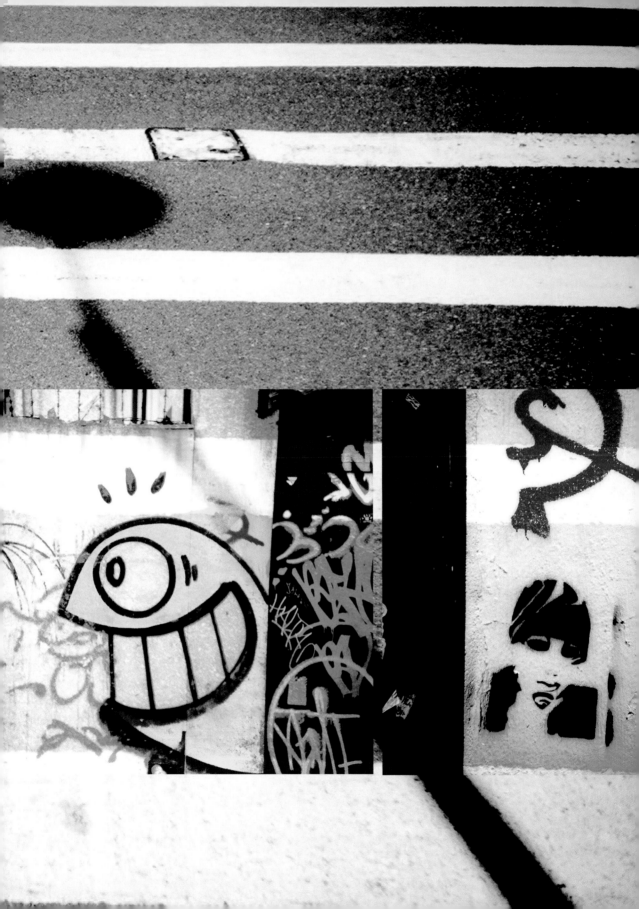

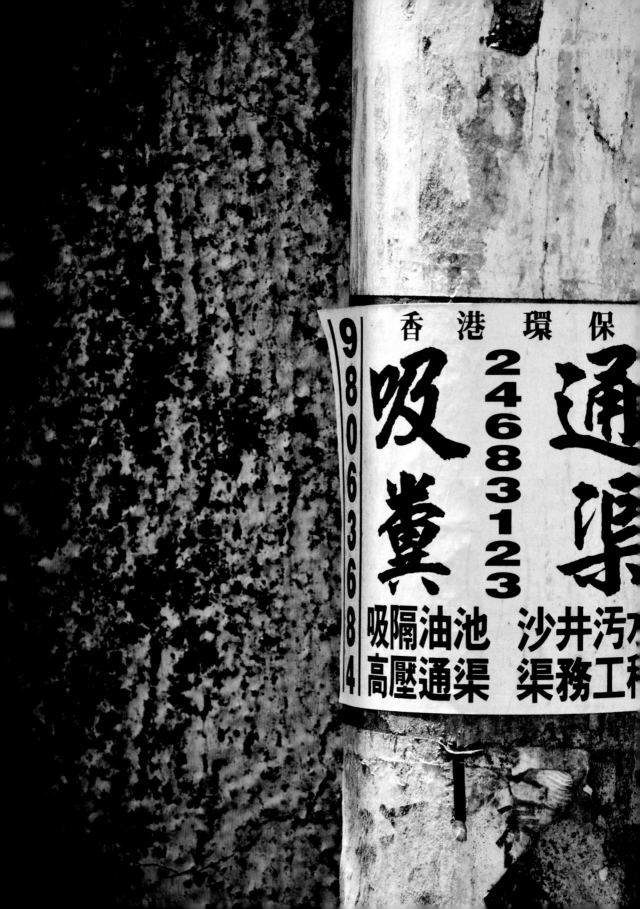

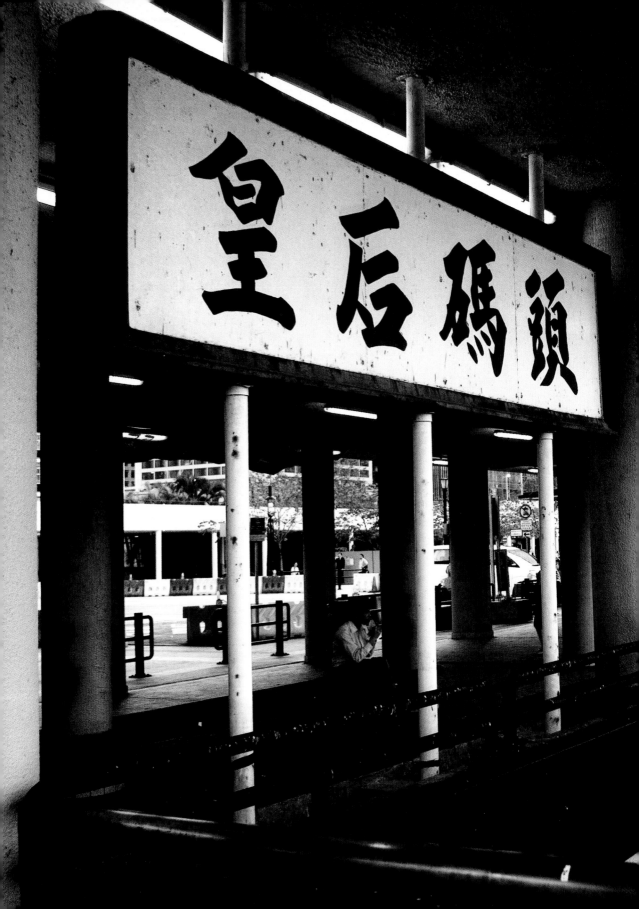

A city always on the go. A throng of humanity close-packed and moving with the industry of a beehive. The busy-ness of business bombarding the senses with its glossy, brand-conscious beauty at every corner.

香港是個不斷行進中的城市。大羣人潮像蜂巢裡勤勞忙碌的蜜蜂，雖然擁擠不堪，卻又井然有序。繁忙的商務，用光鮮亮麗、充滿品牌意識的美感，無處不在、不斷地轟擊人們的感官。

Albert Wen Wanchai 灣仔

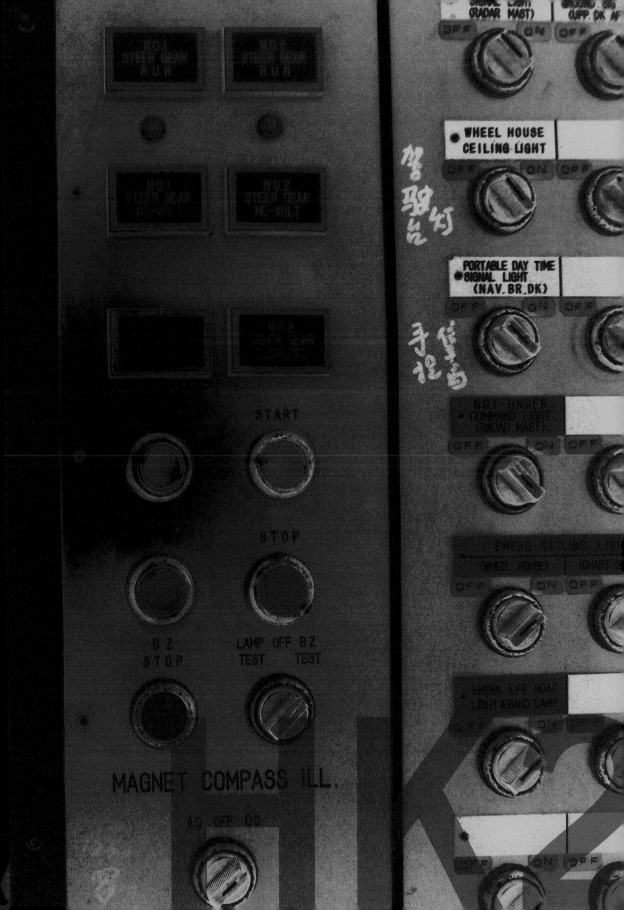

柴灣 Chai Wan　中環 Central　石硤尾 Shek Kip M

北角 North Point　旺角 Mong Ko　鰂魚涌 Quarry Ba

太古 Tai Koo　油麻 Yau Ma　筲箕灣 Shau Kei W

Please mind the

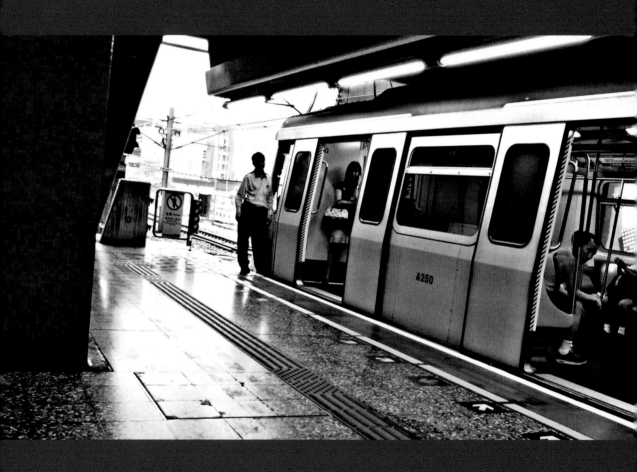

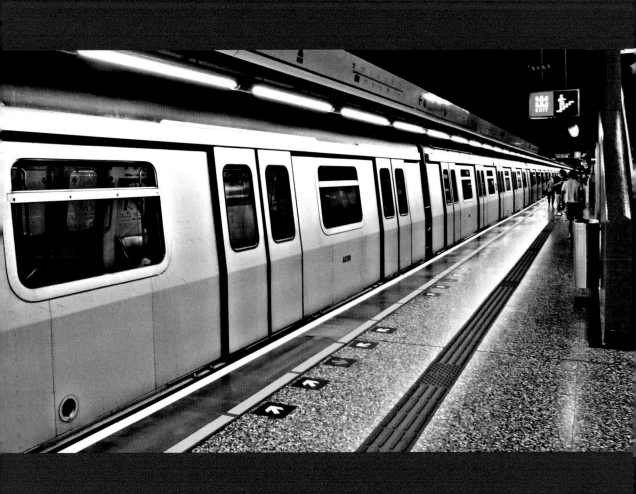

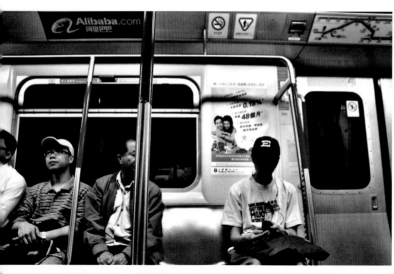

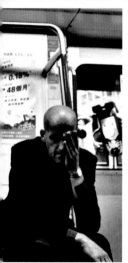
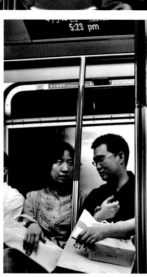
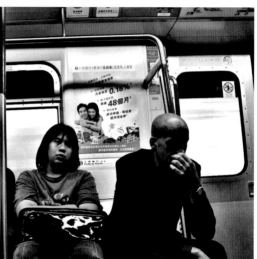

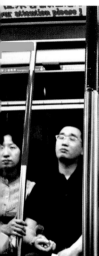
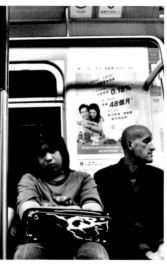
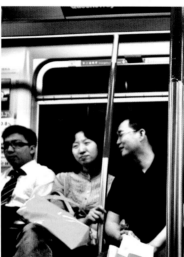

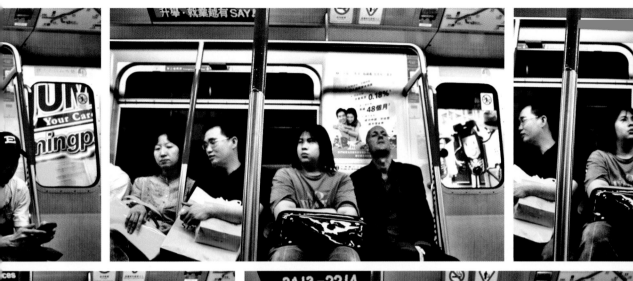

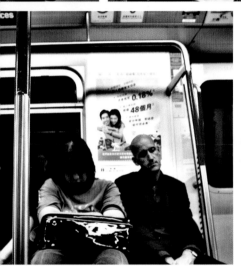

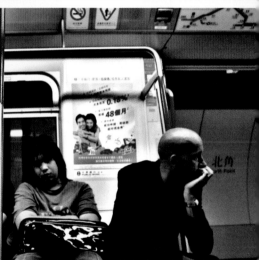

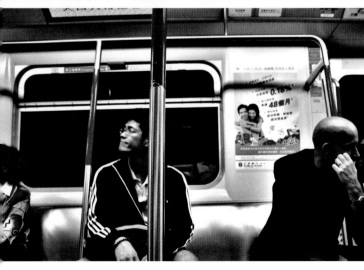

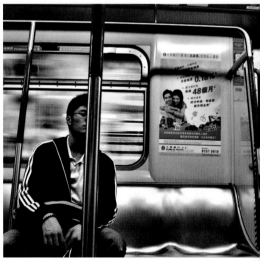

中環
Central

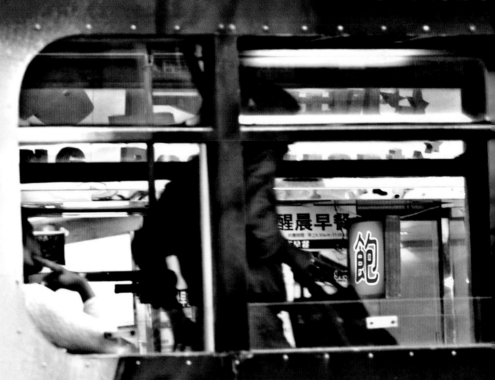

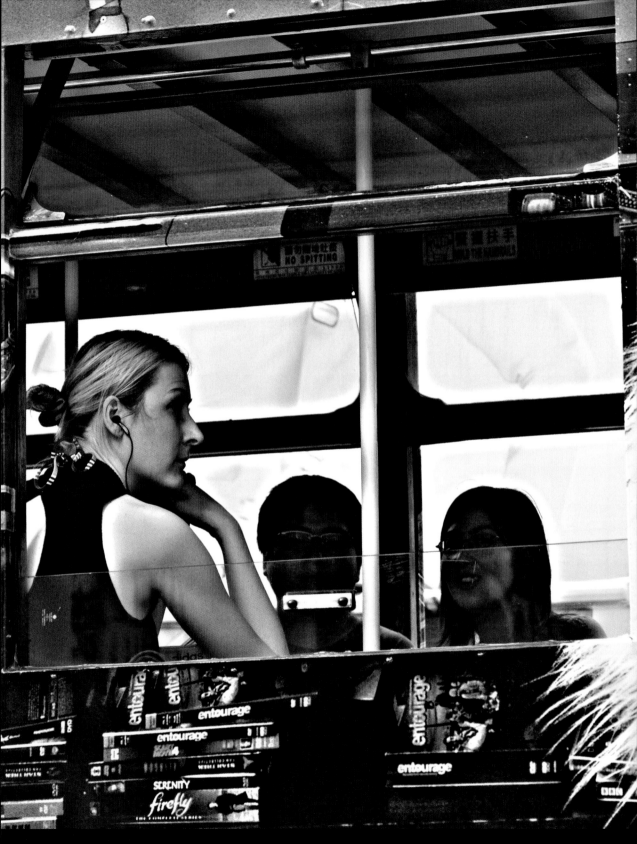

TIEMAS

Limited Edition
Exclusive at On Pedder

TOY WATCH

2008 Les Fleurs Collection
客戶服務熱線: (852)2766 3693 www.3D-GOLD.com

YOKOSO! JAPAN
www.welcome2japan.hk/

精采活
盡在日

陳丁謙與他的工作夥伴
共創事業高峰，宏利助他們成就夢想。

u miles ahead.
missing out?

NKS
NDON

三百多年歷史

ACK FLEECE
BY
Brooks Brothers

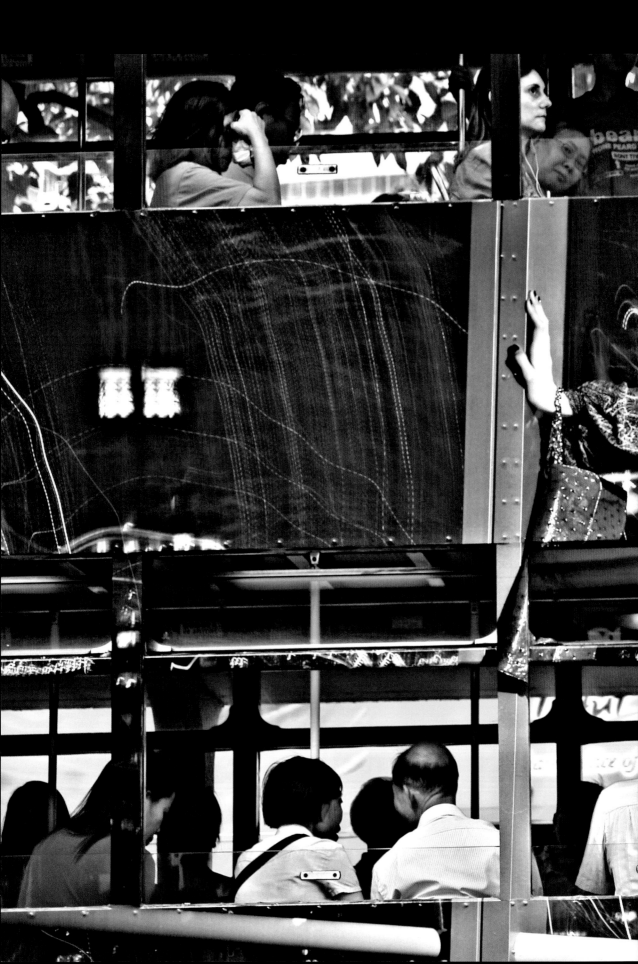

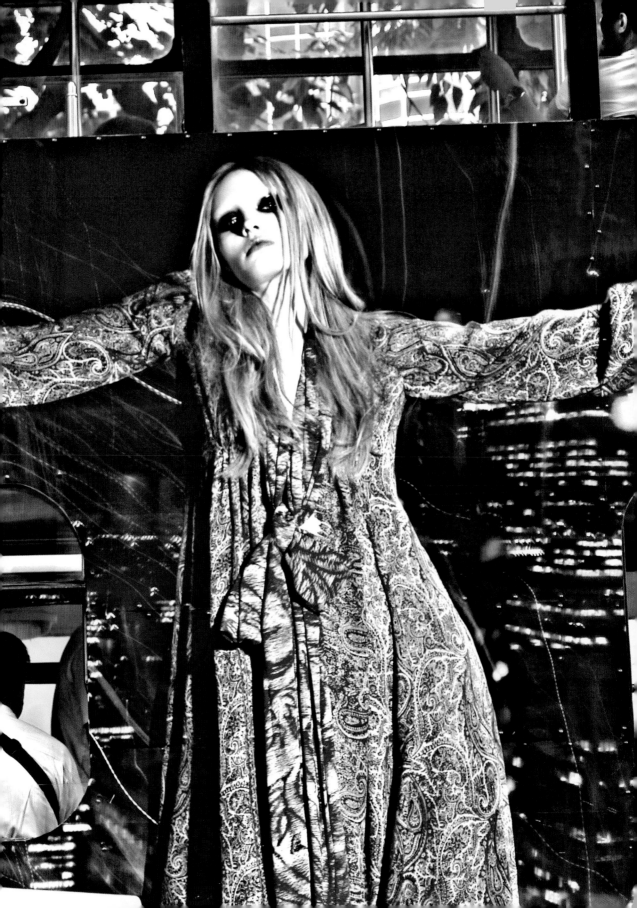

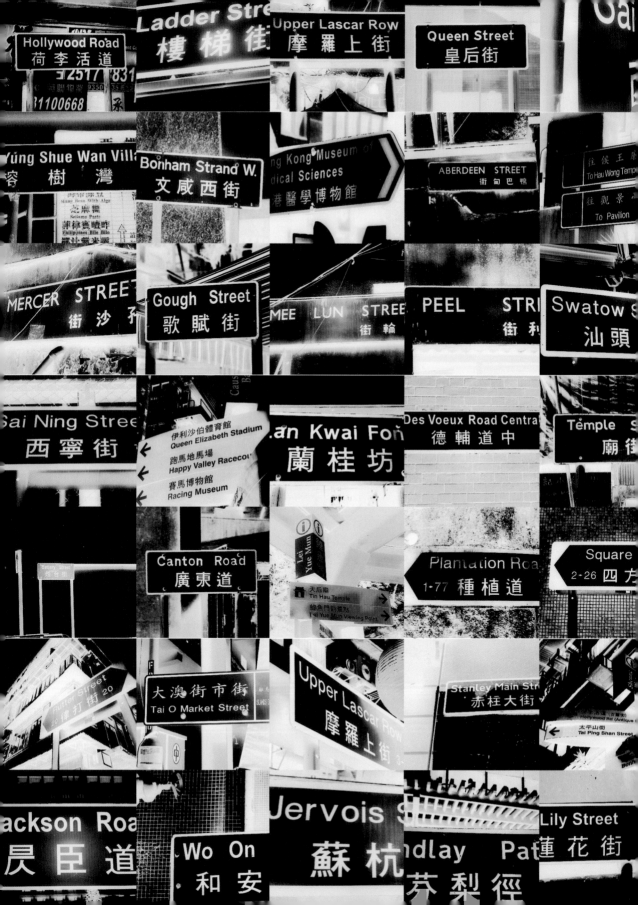

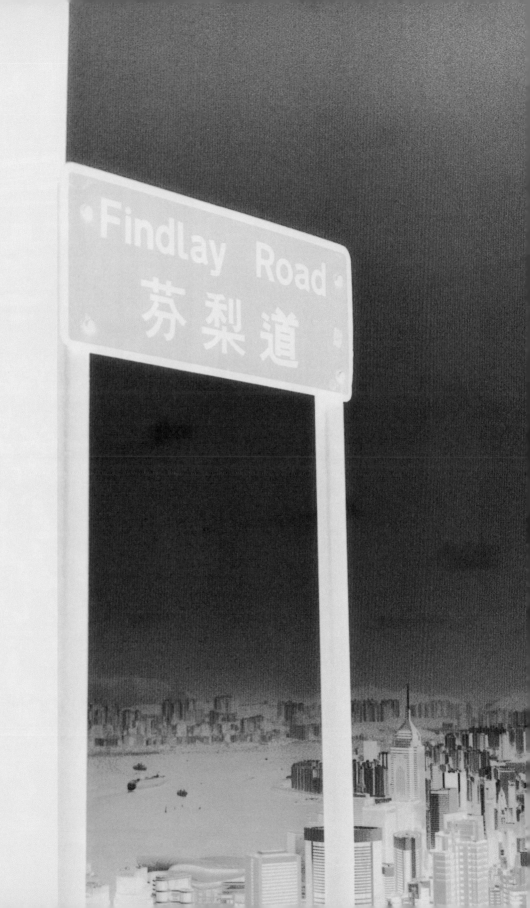

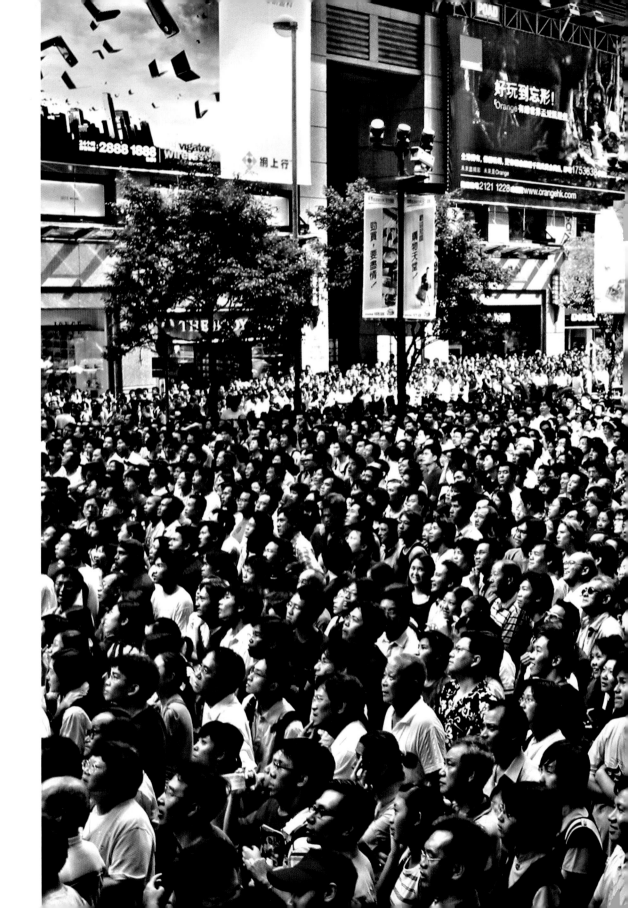

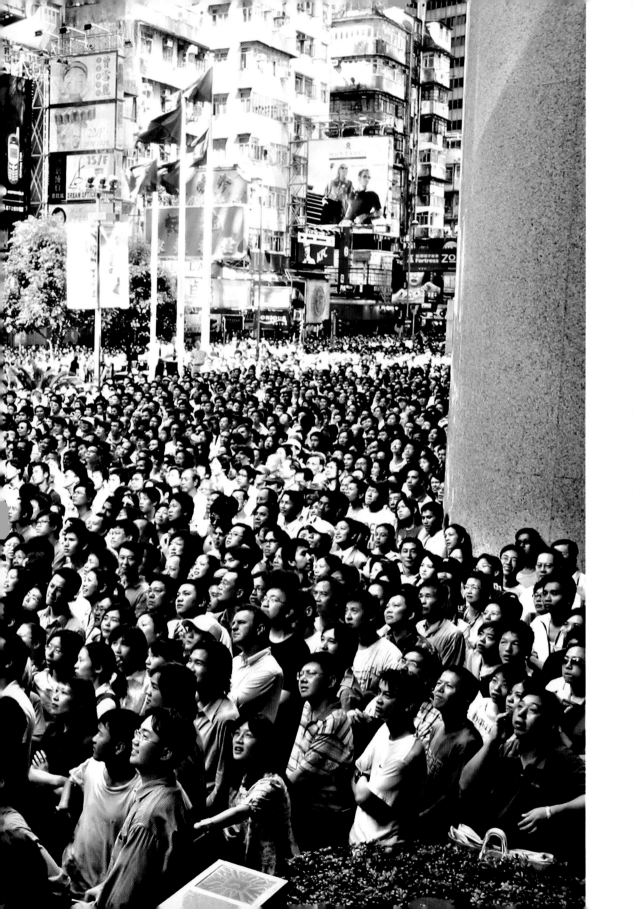

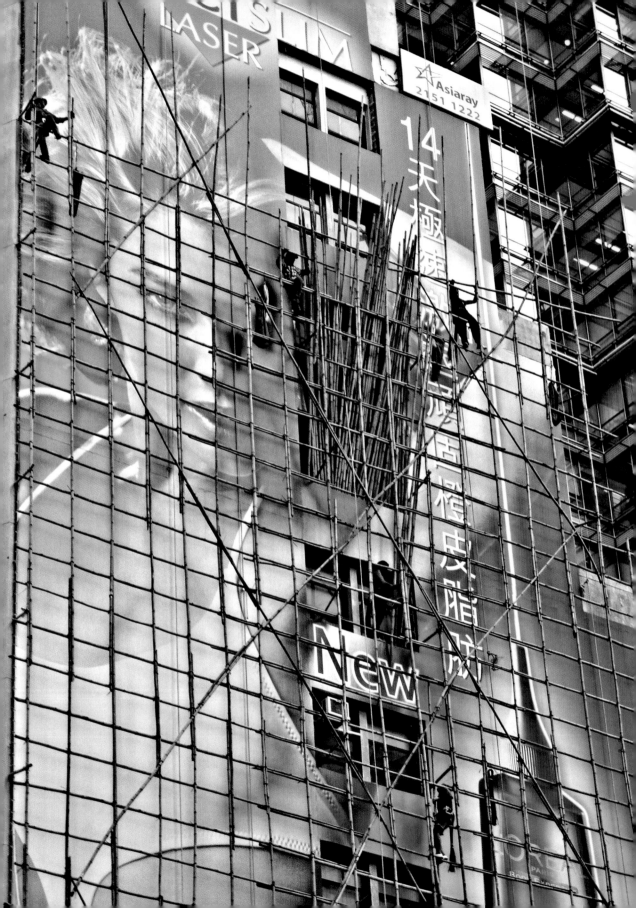

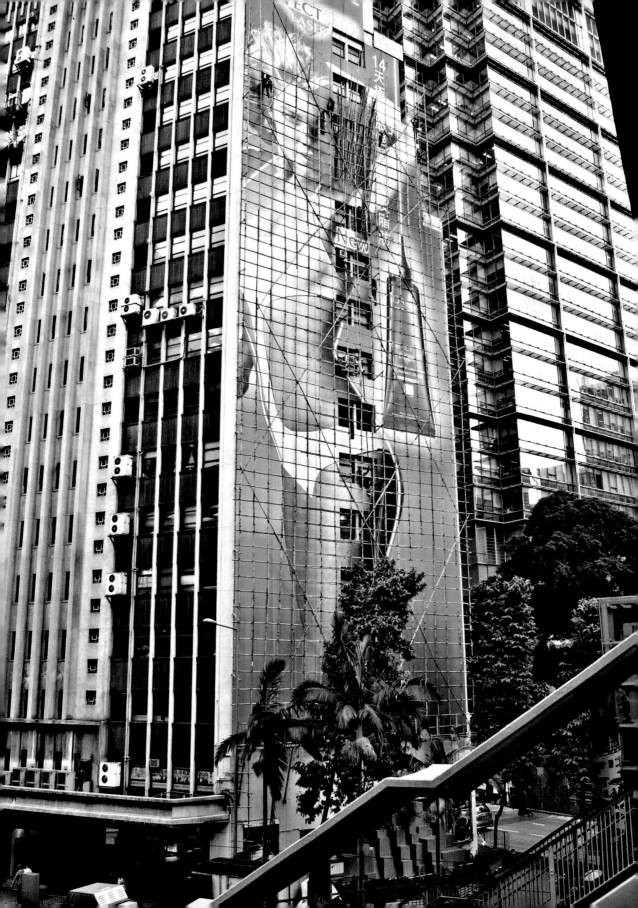

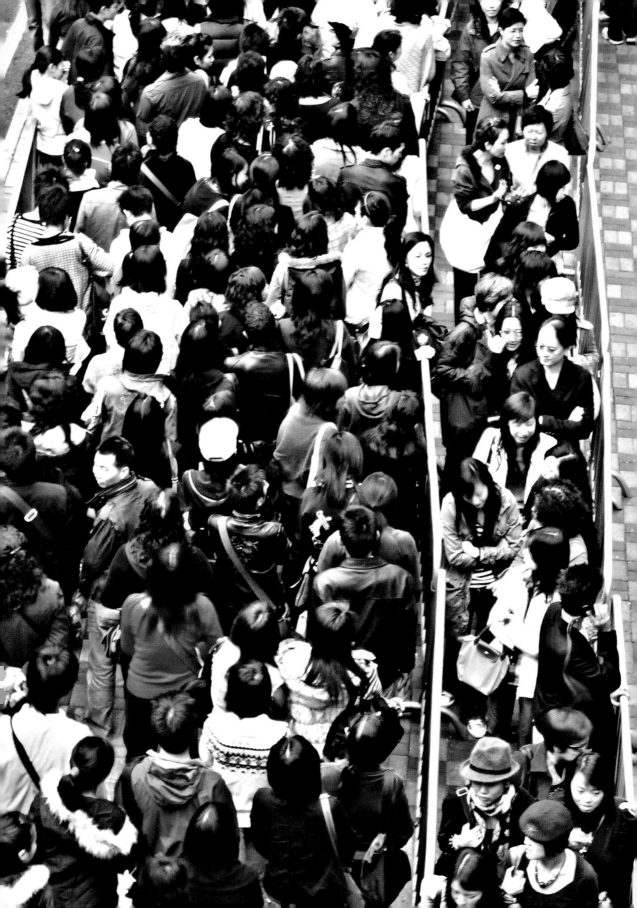

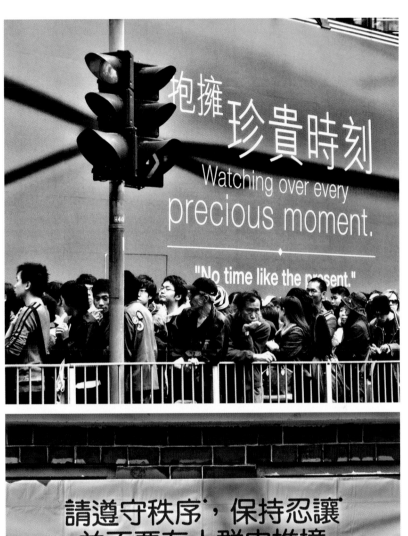

抱擁 珍貴時刻
Watching over every
precious moment.

"No time like the present."

請遵守秩序，保持忍讓
並不要在人群中推撞
Stay calm and
do not push in the crowd

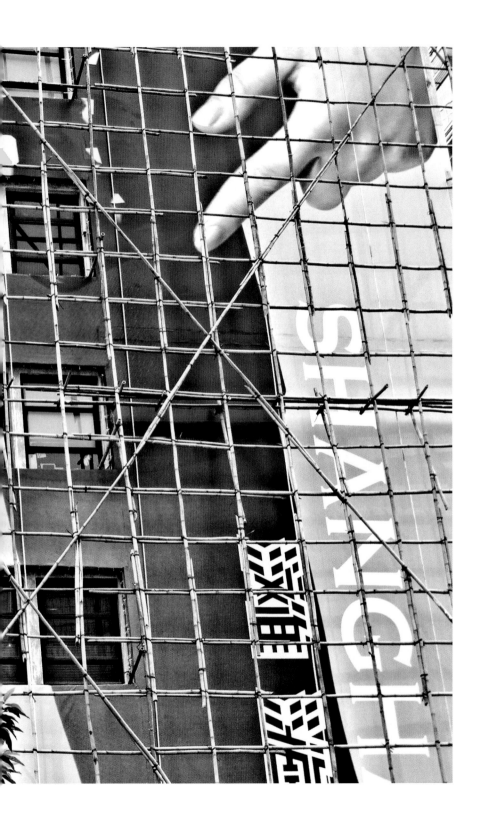

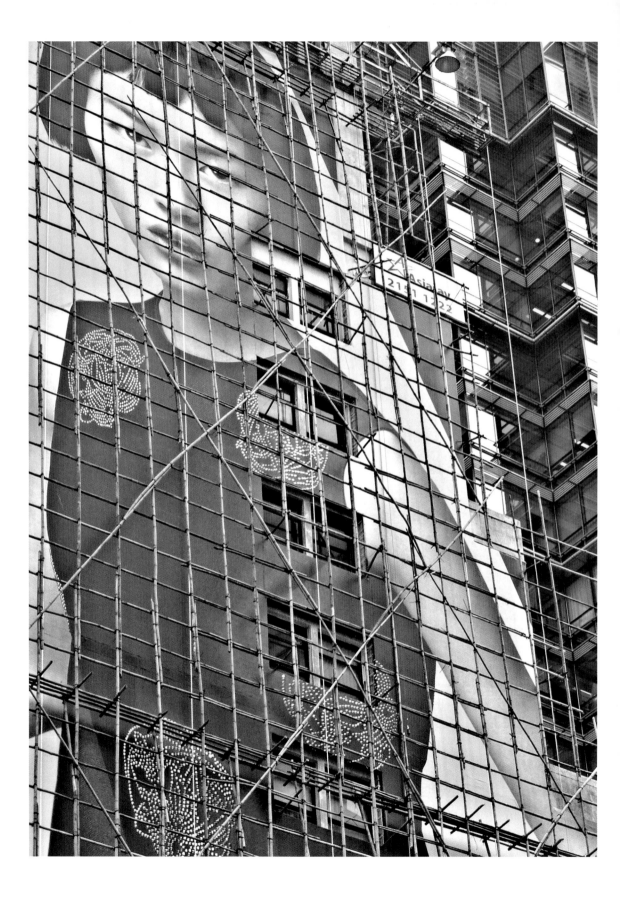

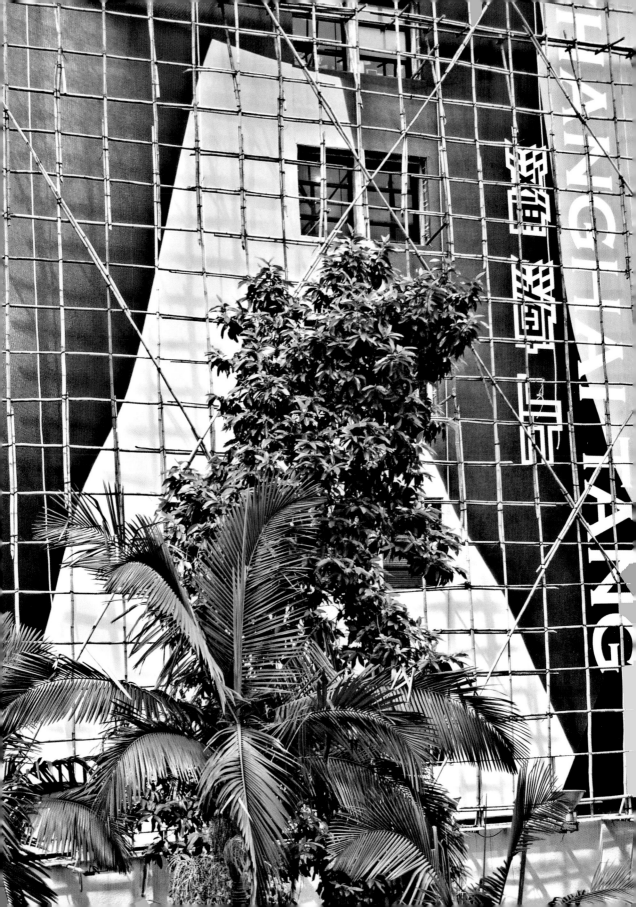

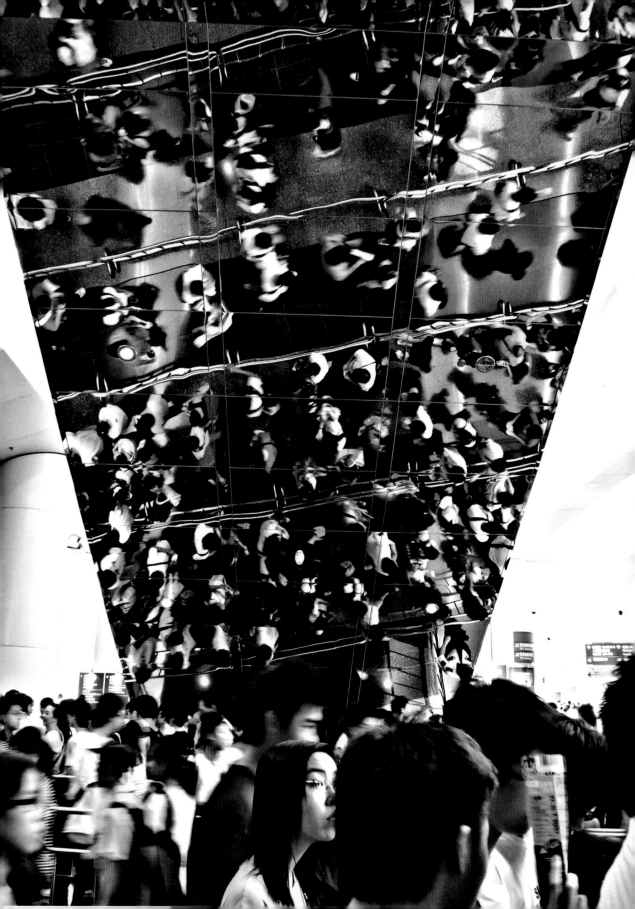

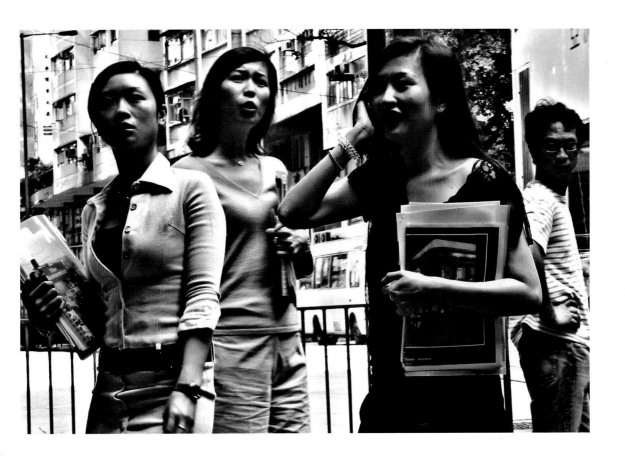

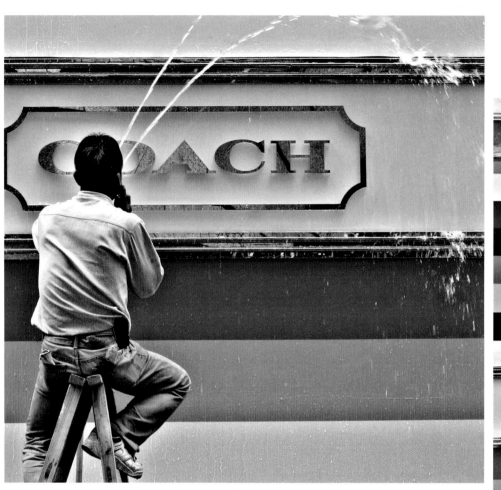

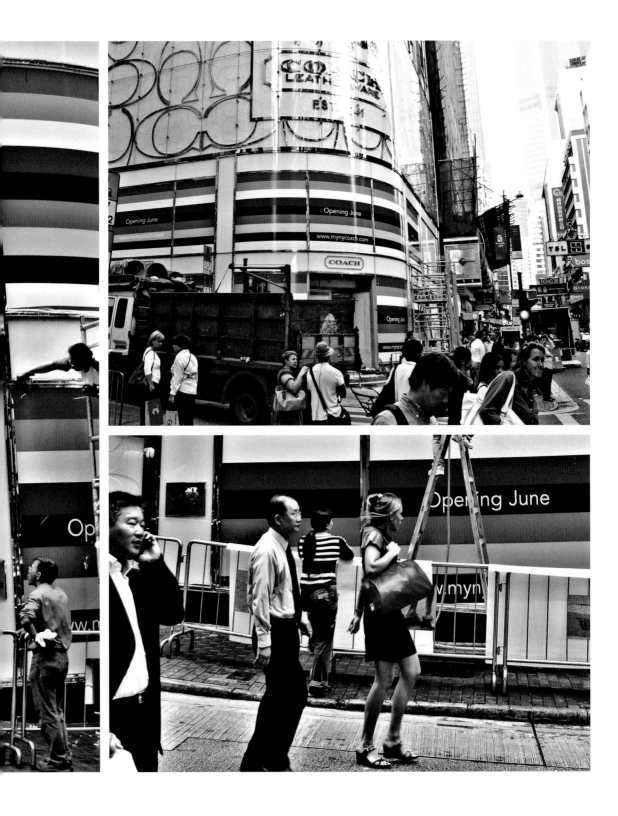

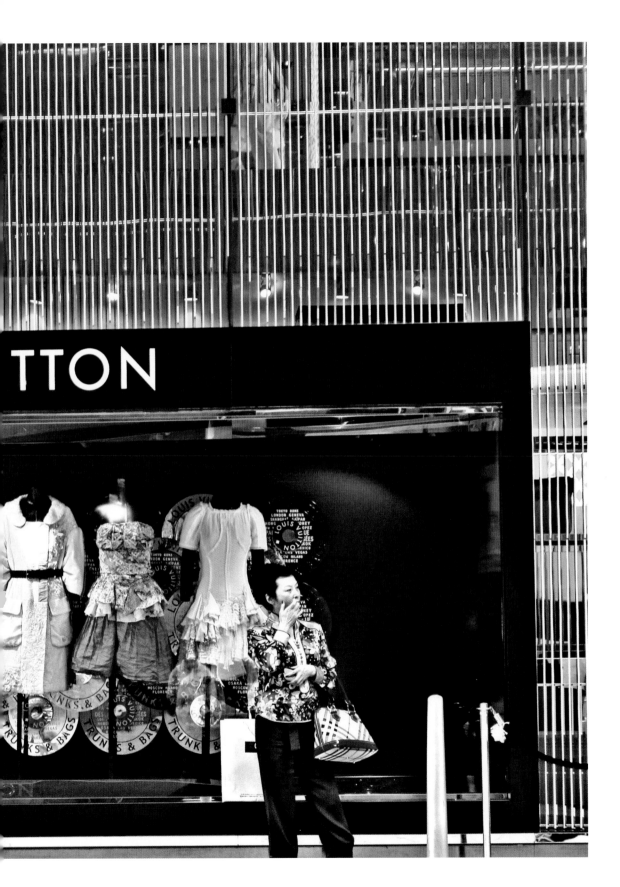

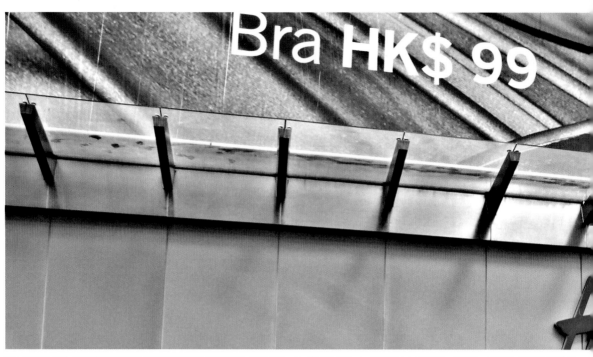

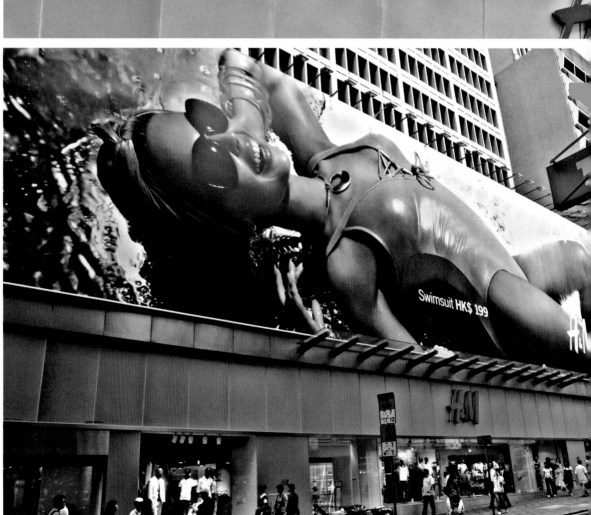

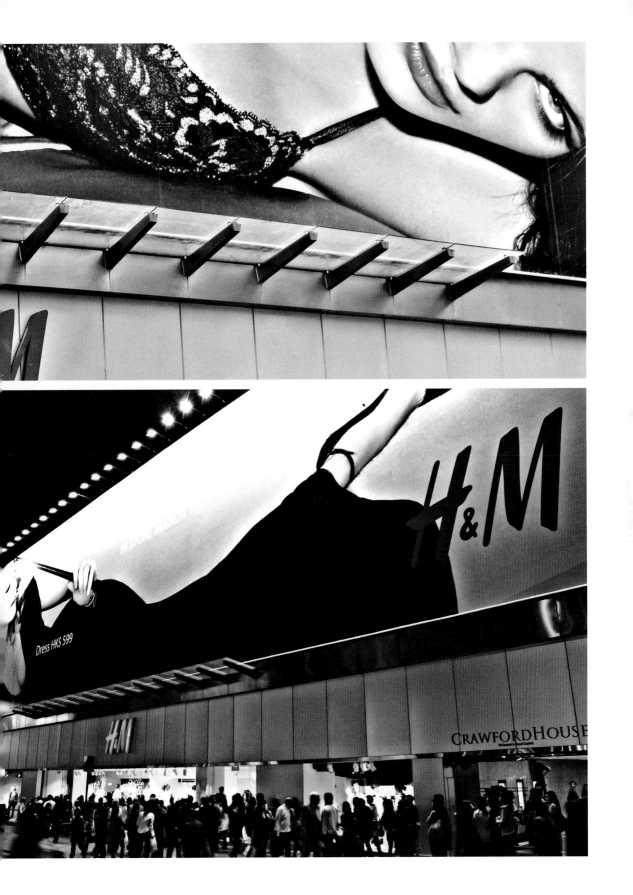

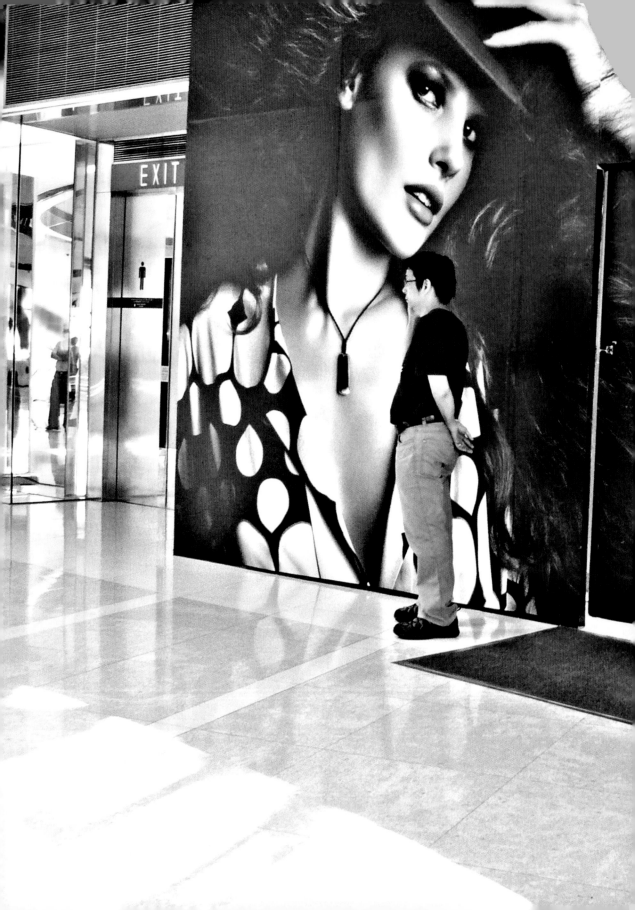

ON[LONGI]NES

The Longines
Master Collection

e is an attitude

BU[RBERRY]

A SPECI[AL]

Available at
Fine Asia（瑞聯錶行） 1/F SOGO

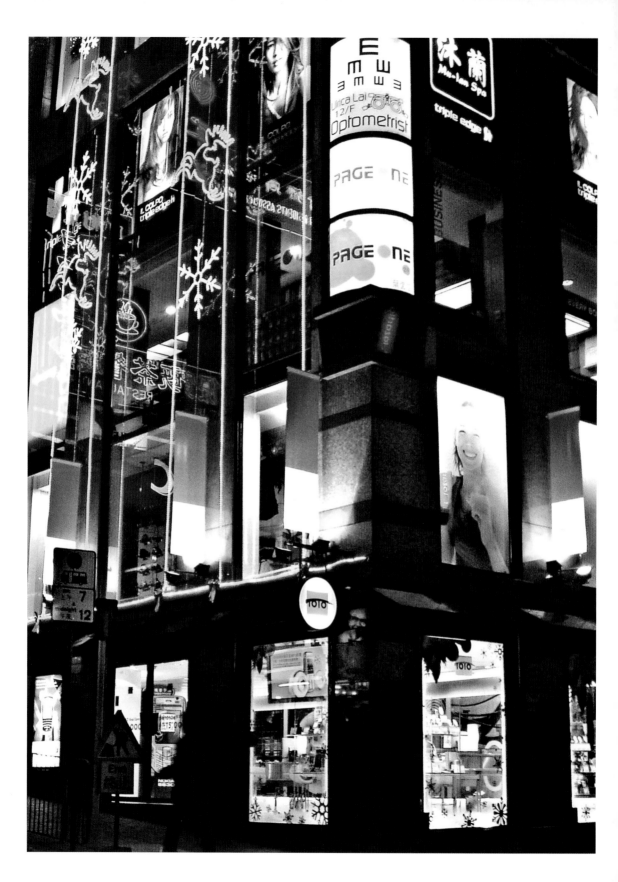

blowfish

高登電腦中心
GOLDEN COMPUTER CENTRE
高登電腦
GOLDEN COMPUTER

藥材

little black dress

ee

PEOPLES

PE

金濤芬蘭浴
電梯按3字
天天電腦網吧
Internet Game Room

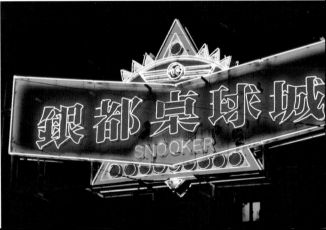

銀都桌球城
SNOOKER

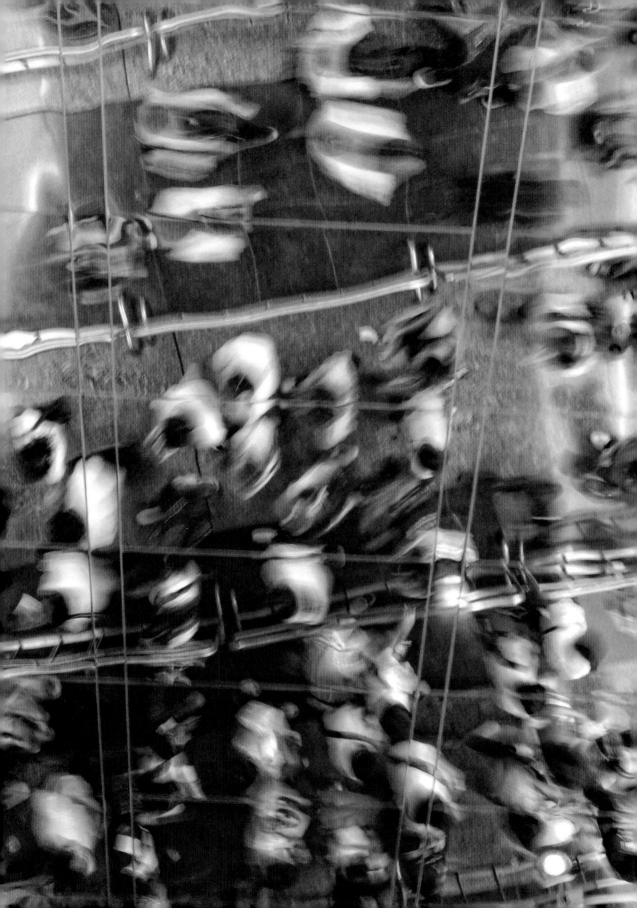

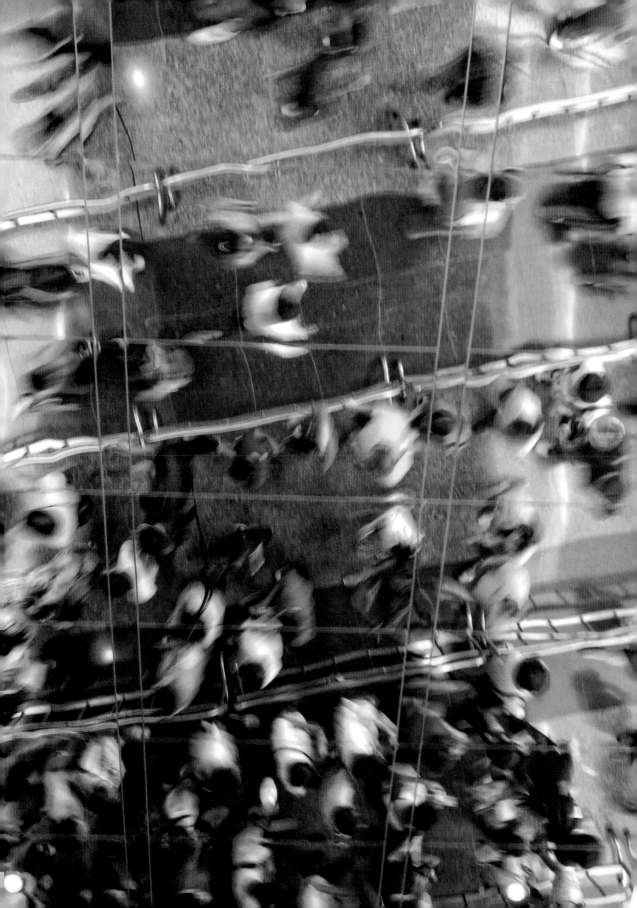

A cultured, storied people. Traditions overlap with everyday life in a panoply of colors.

一羣擁有文化和故事的人。傳統和日常生活穿插重疊成多姿多彩的盛大場面。

Blair Dunton SOHO 蘇豪

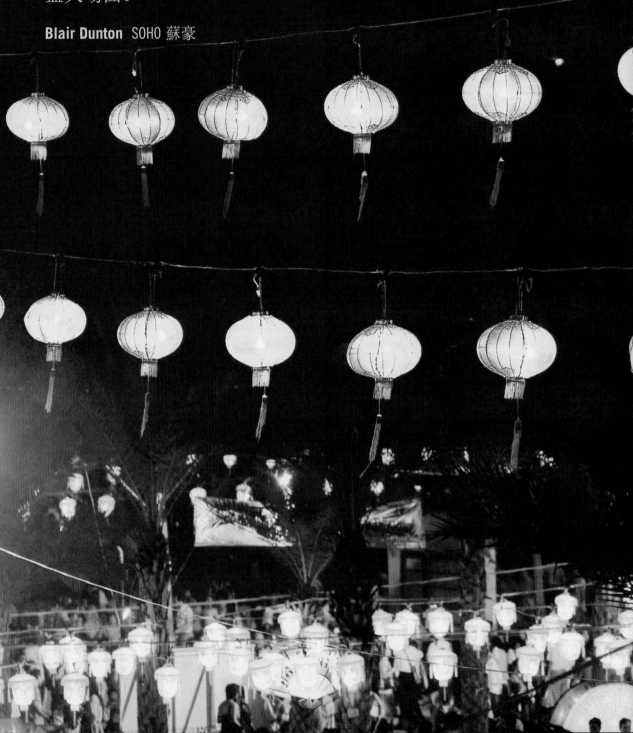

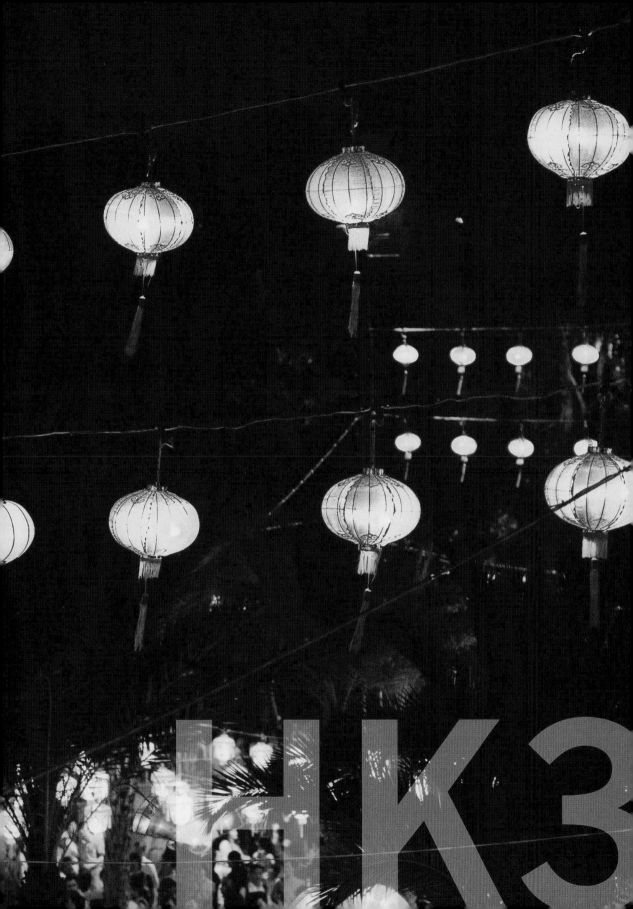

出入平安

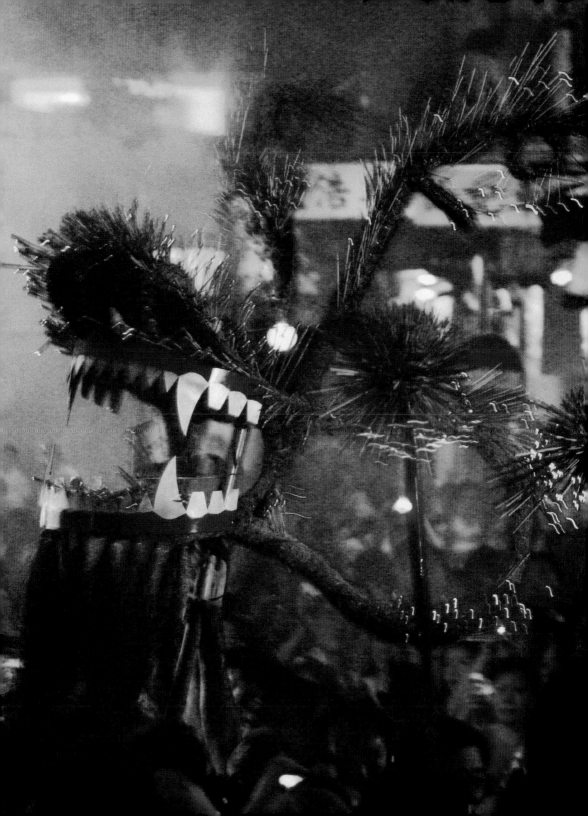

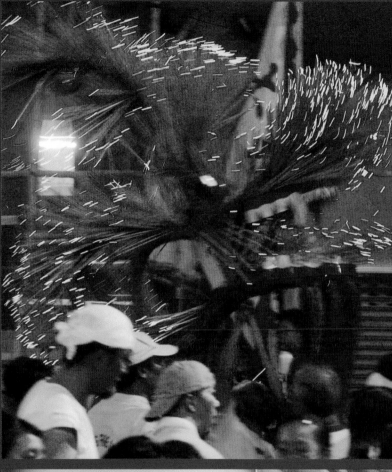

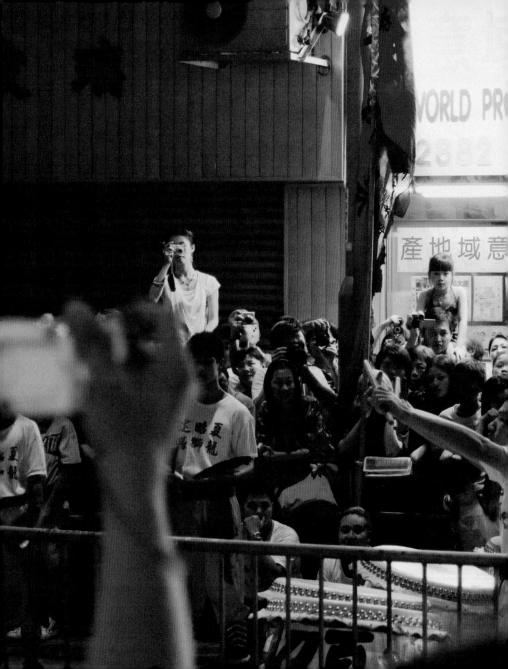

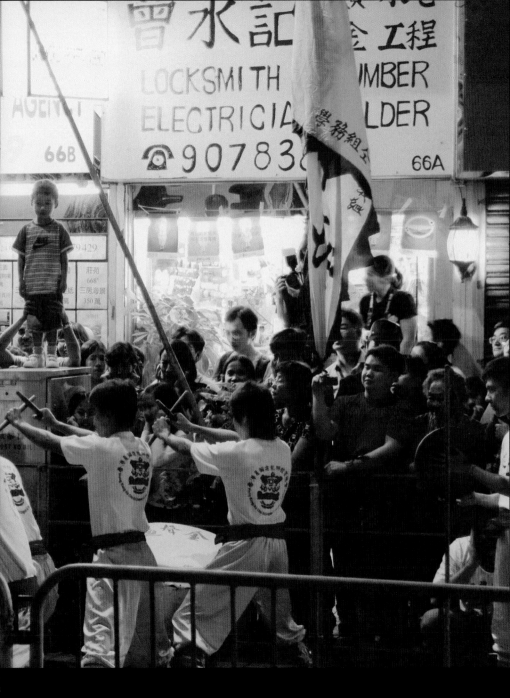

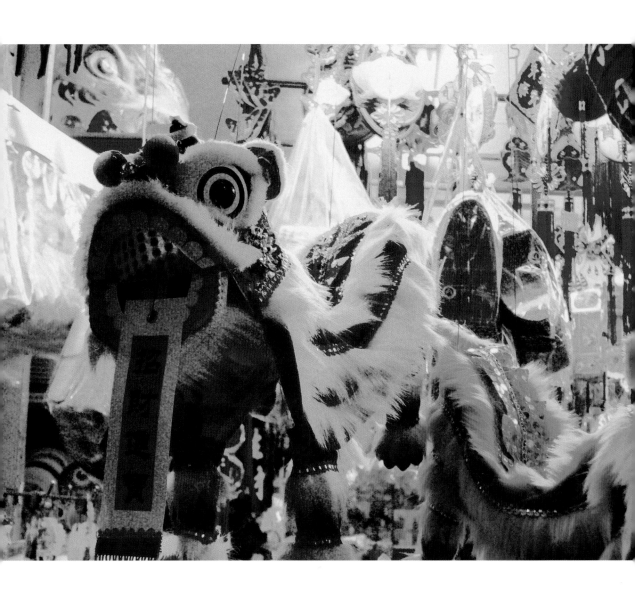

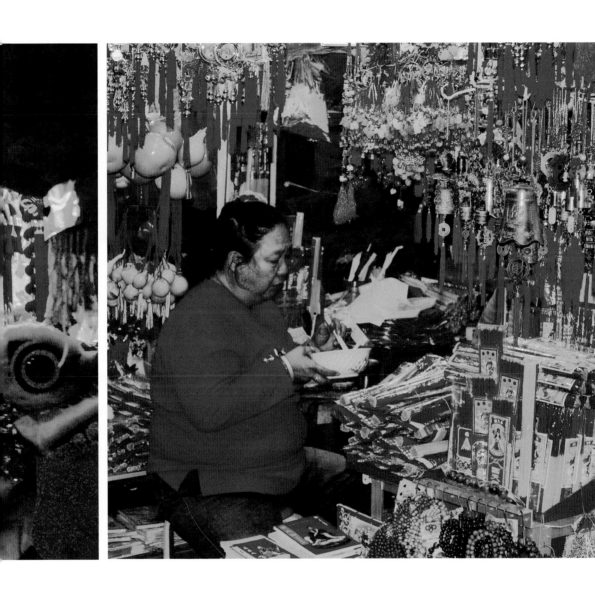

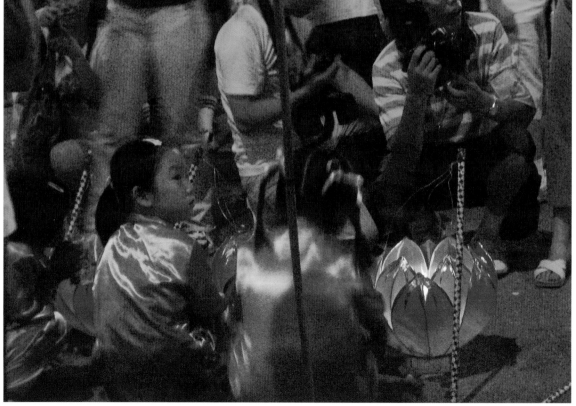

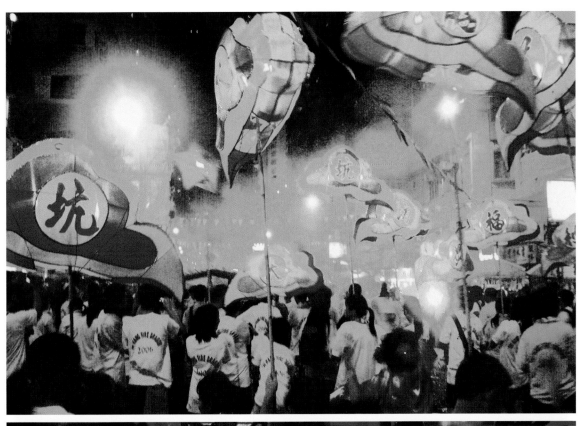
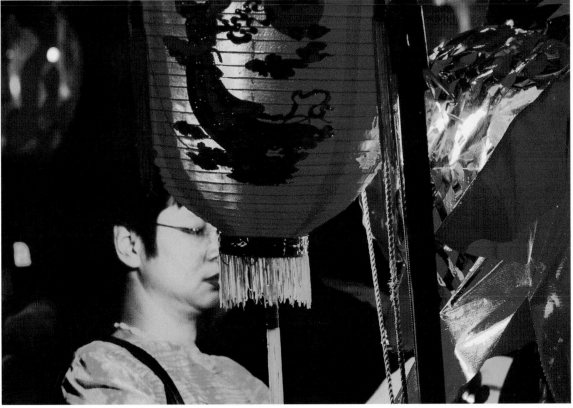

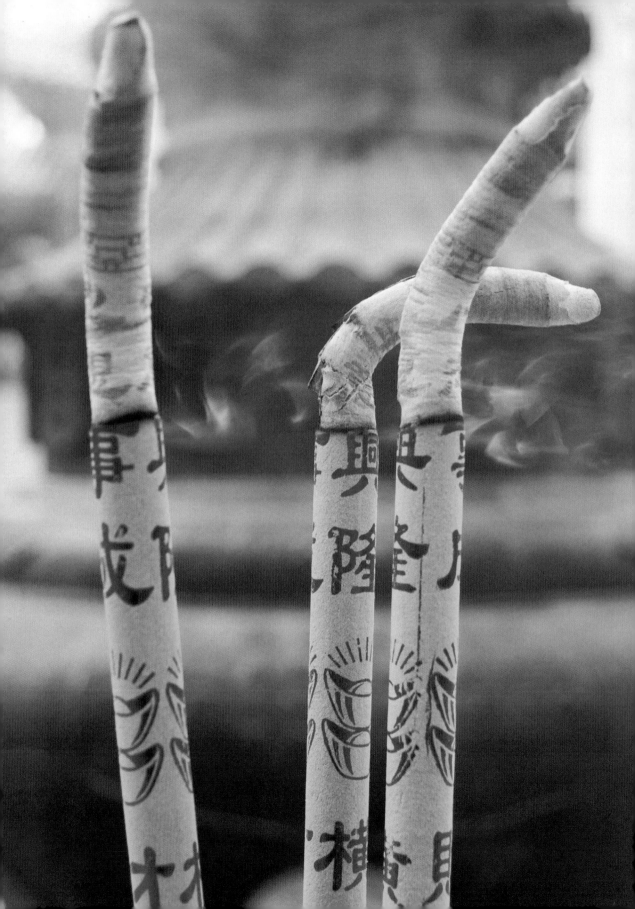

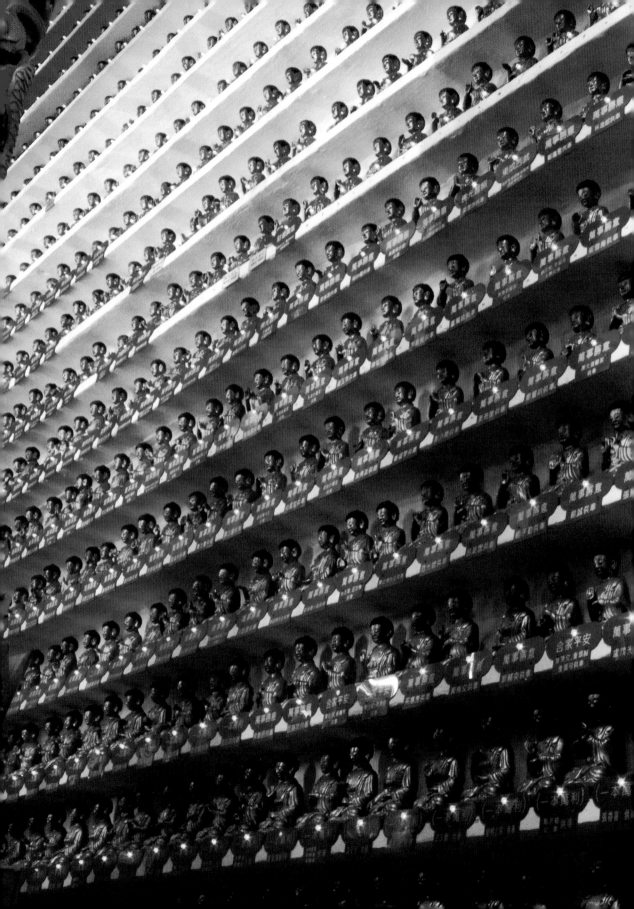

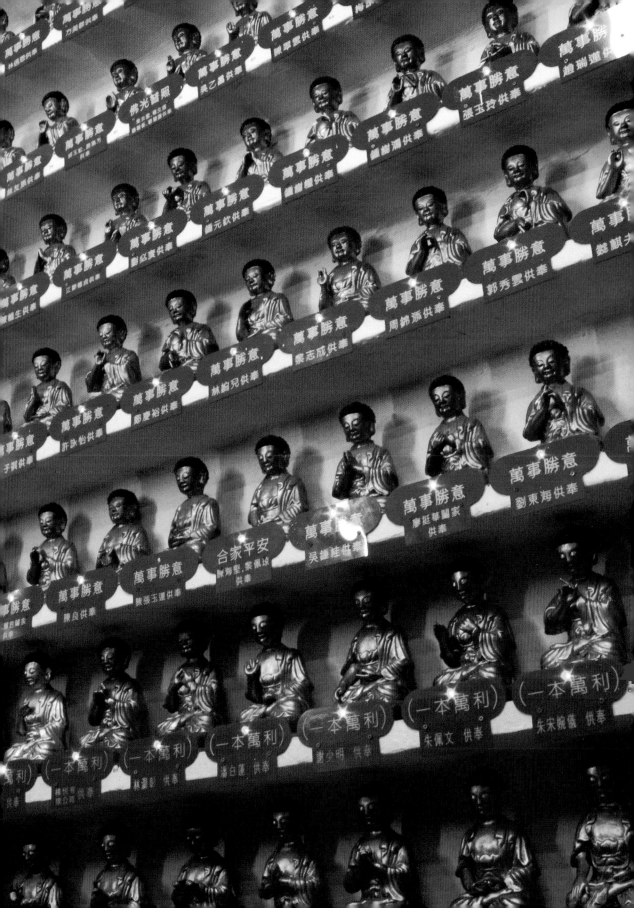

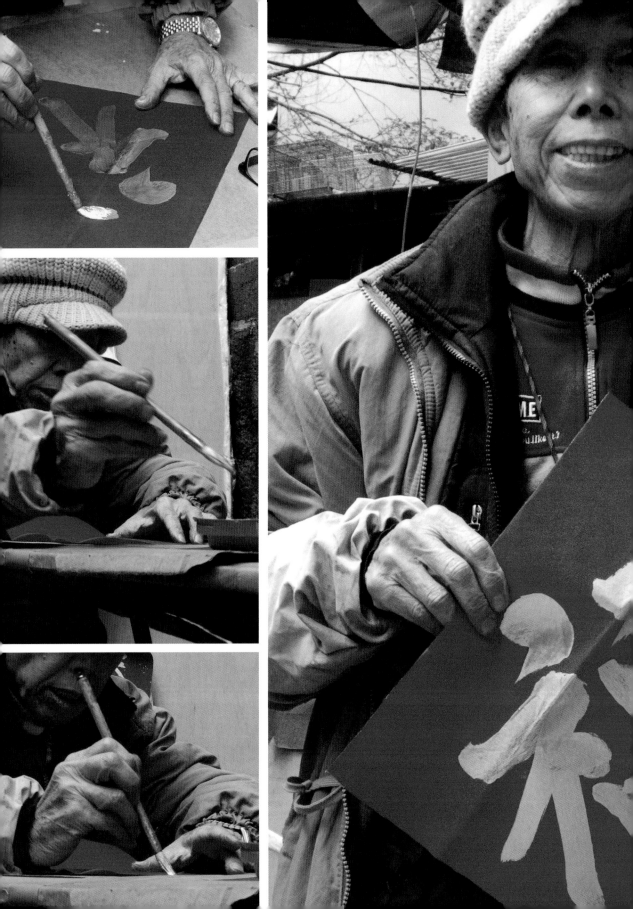

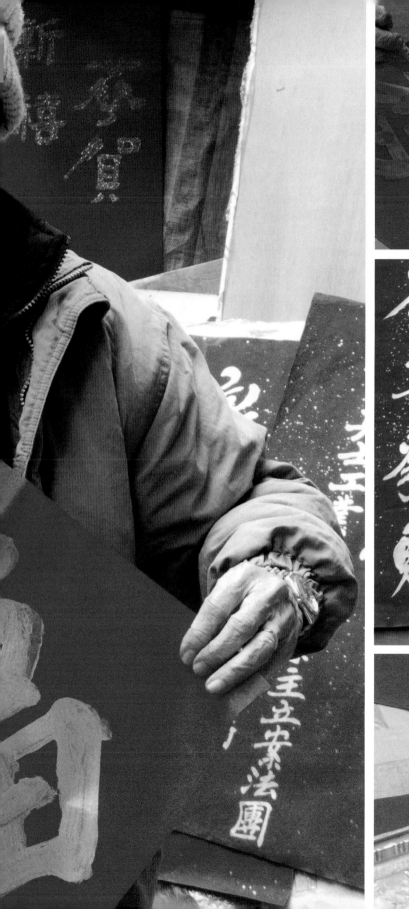

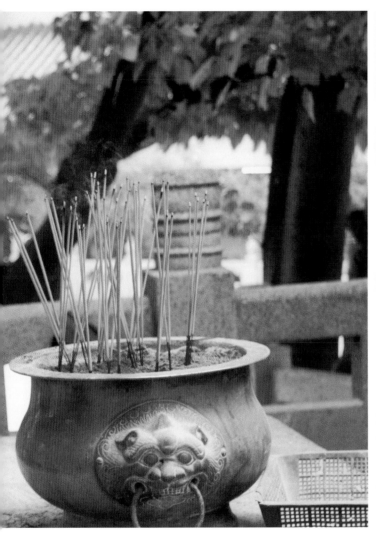
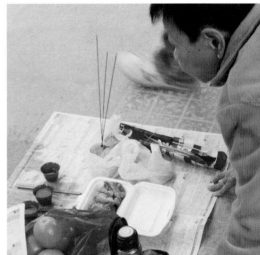

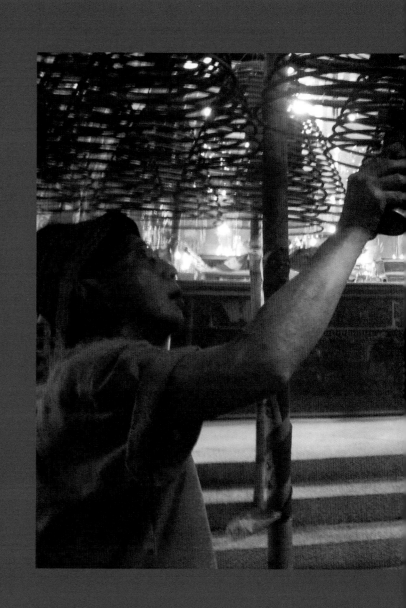

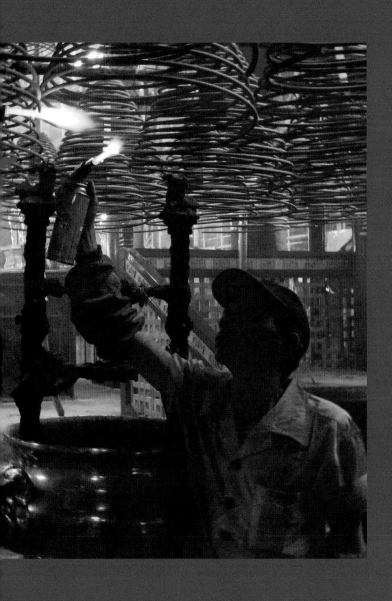

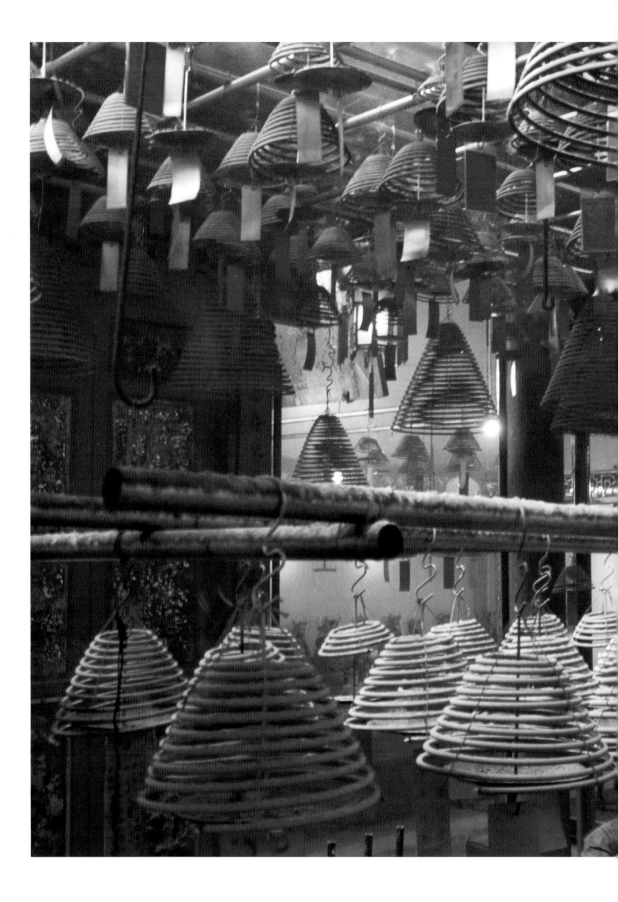

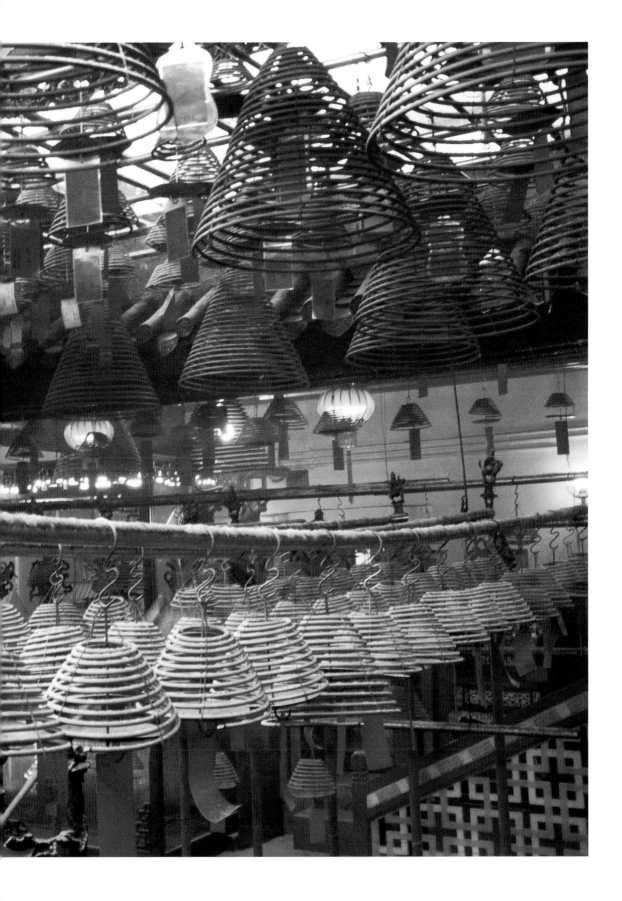

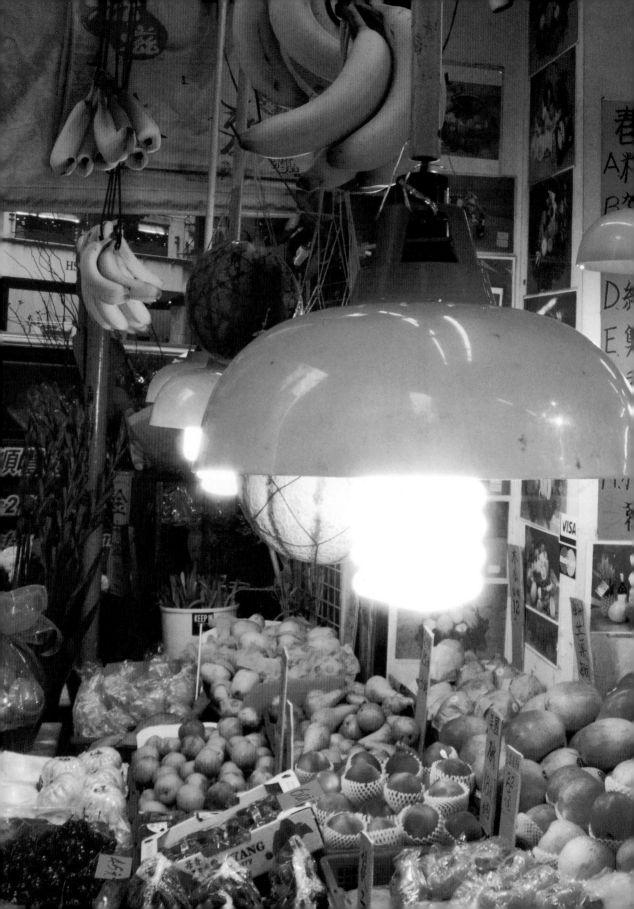

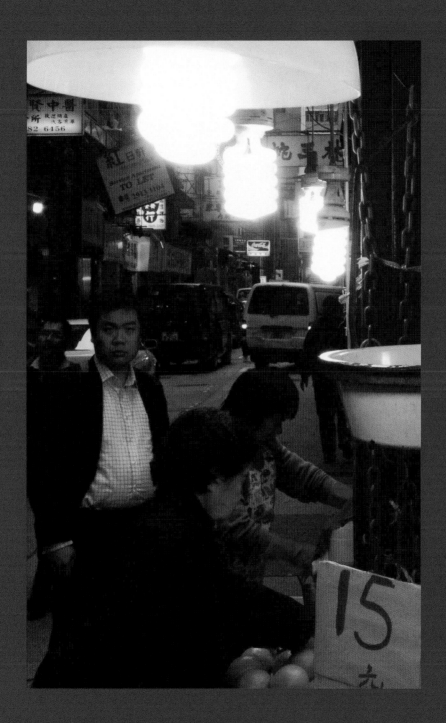

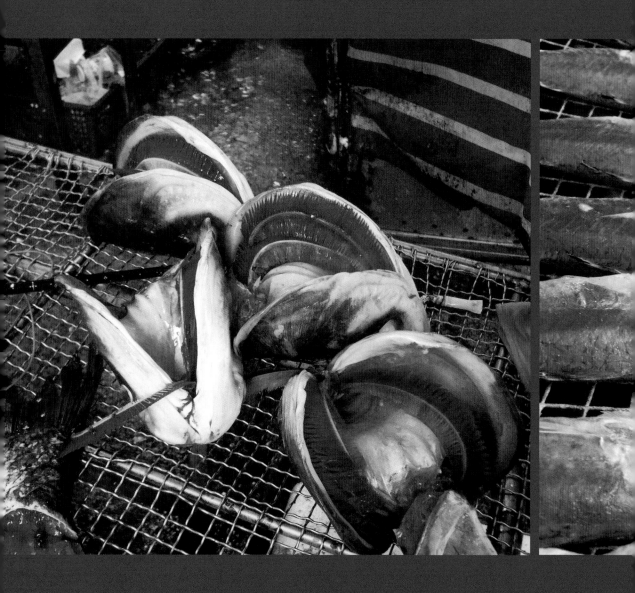

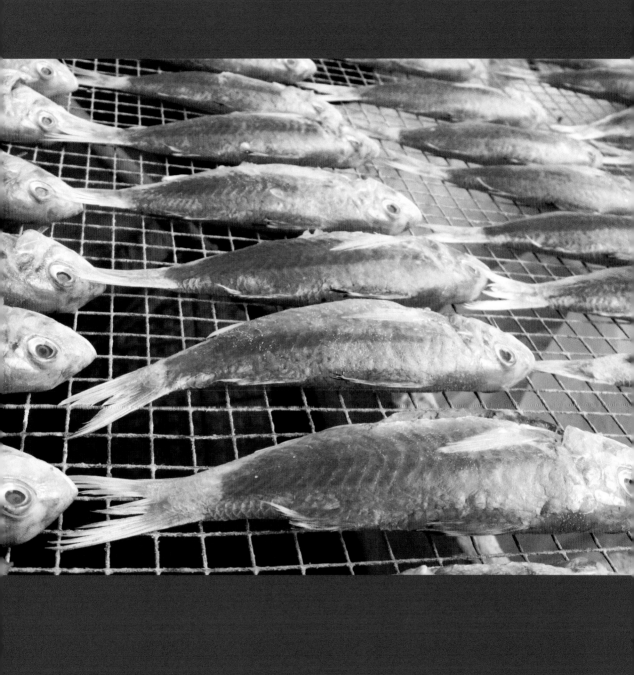

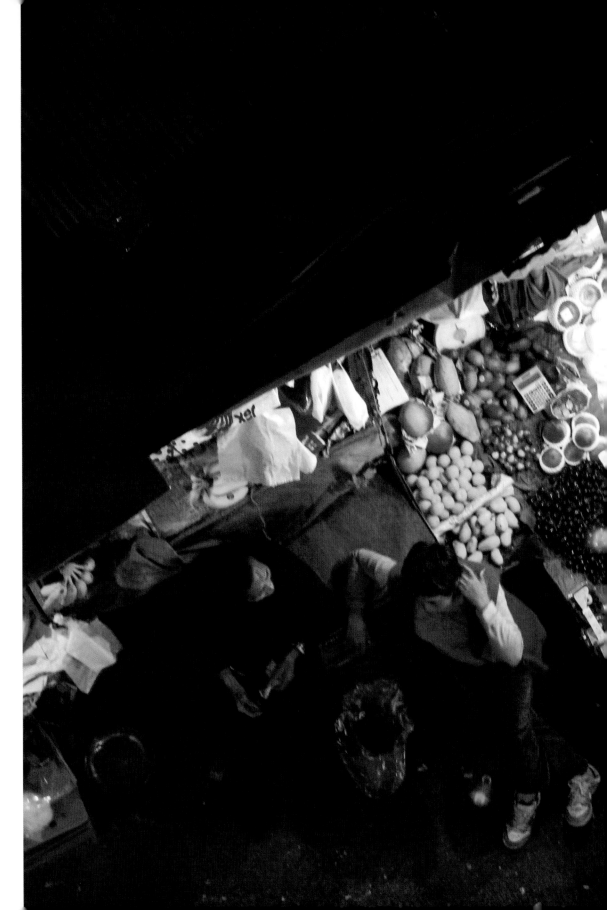

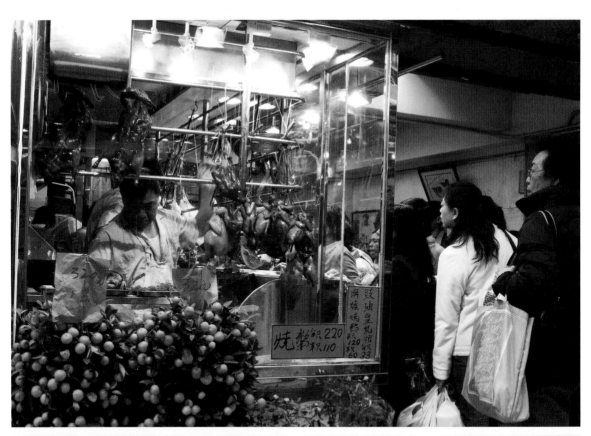

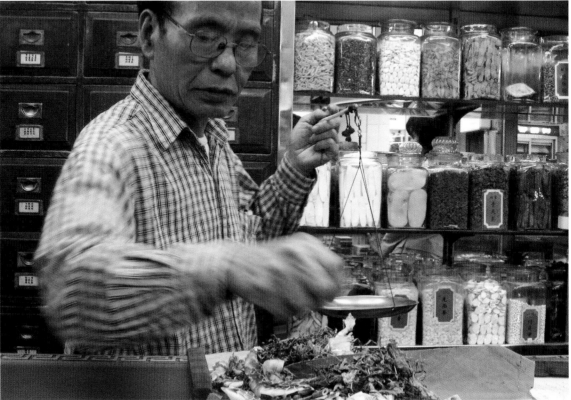

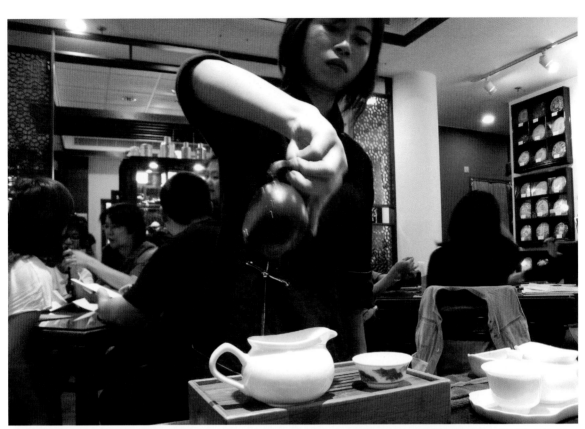

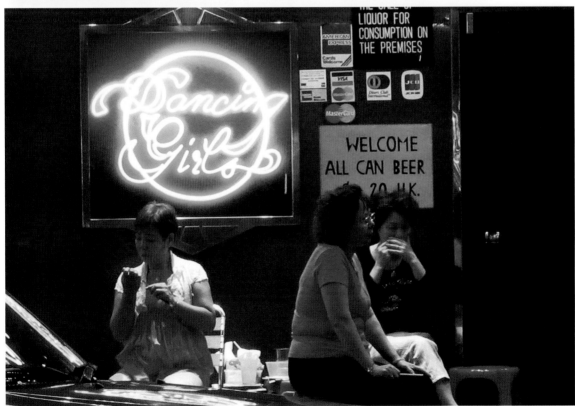

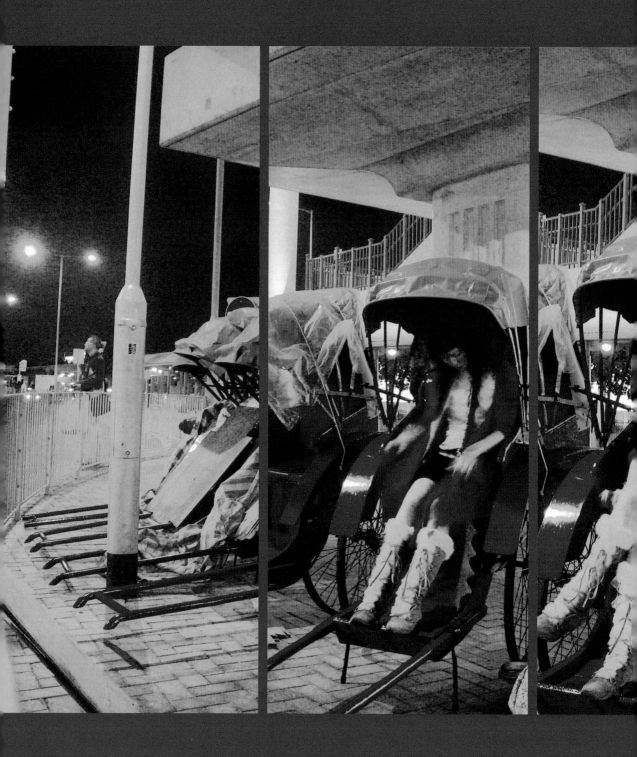

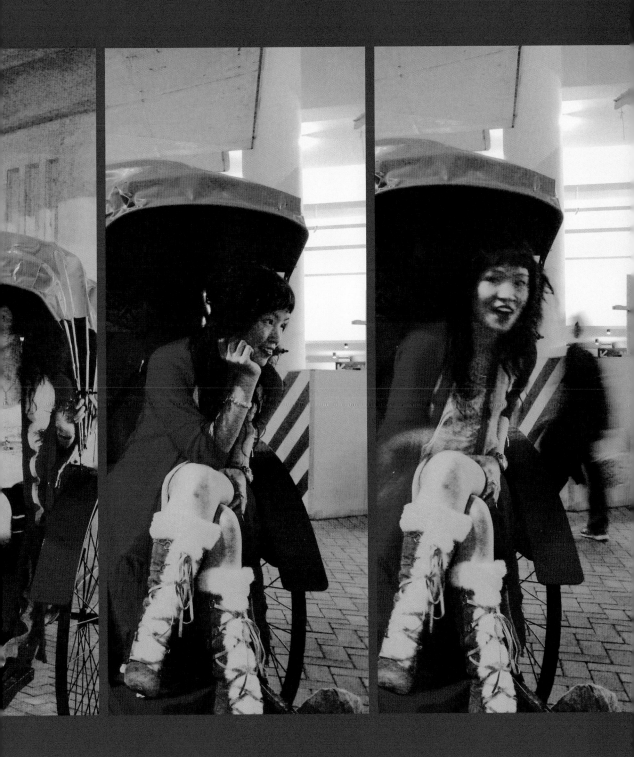

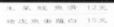

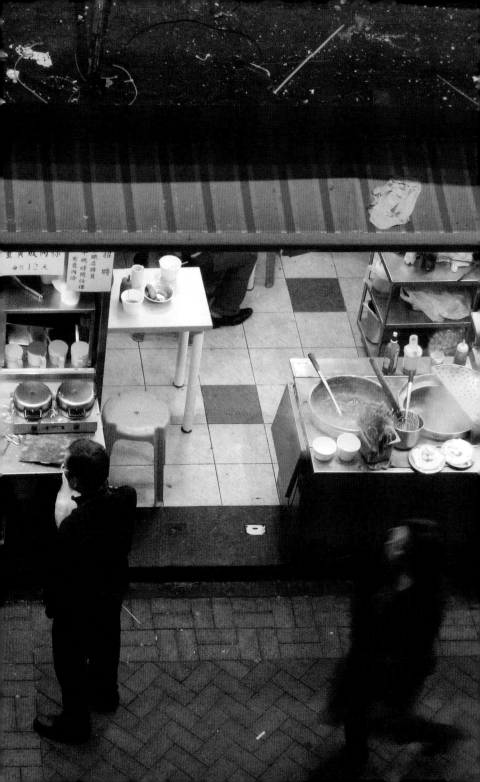

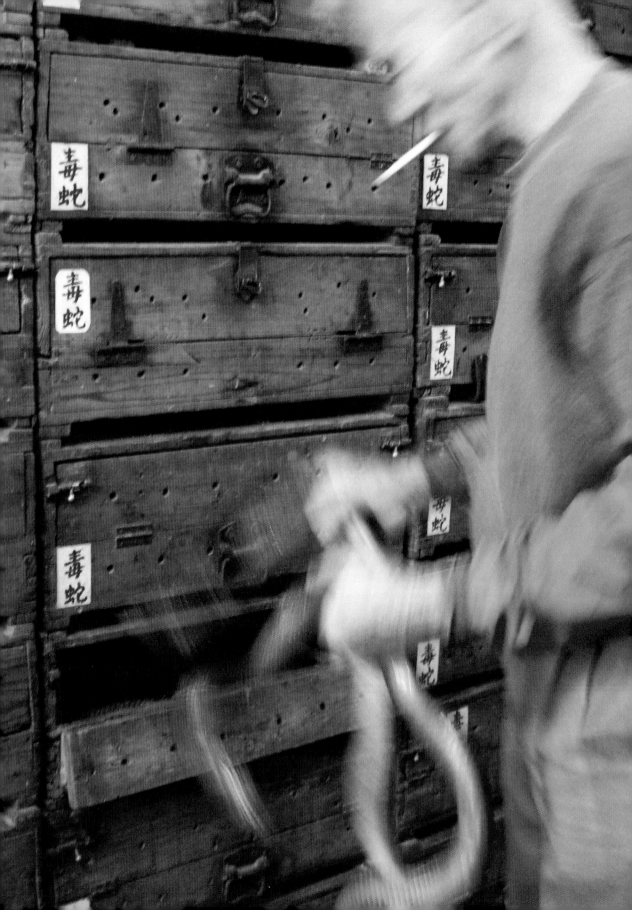

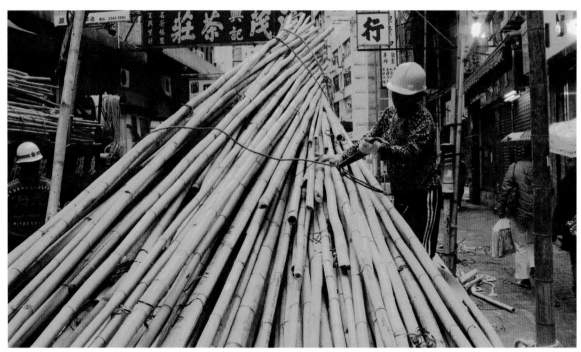

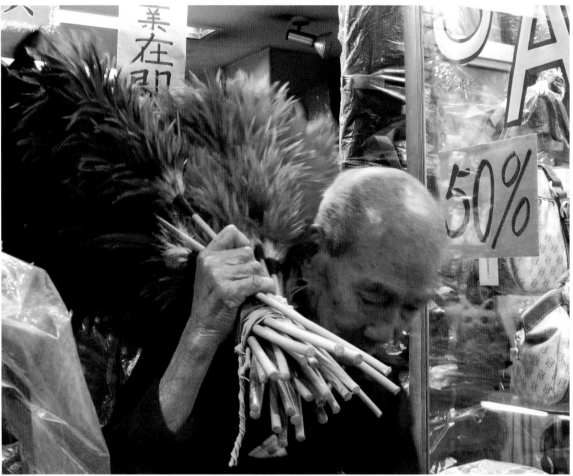

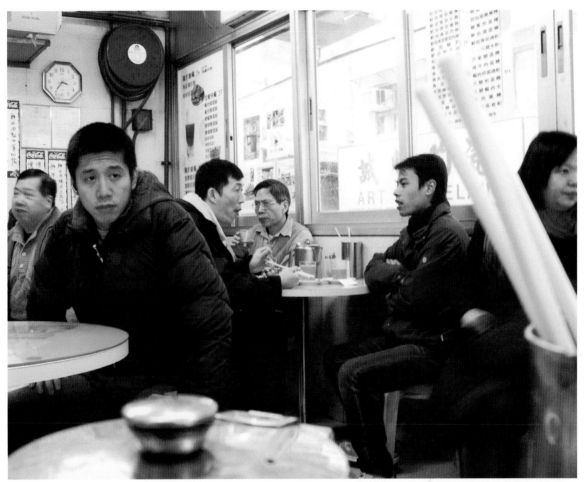

HYSTEVICAL WAVE SHANGHAI NOODLE
灣浪上海麵

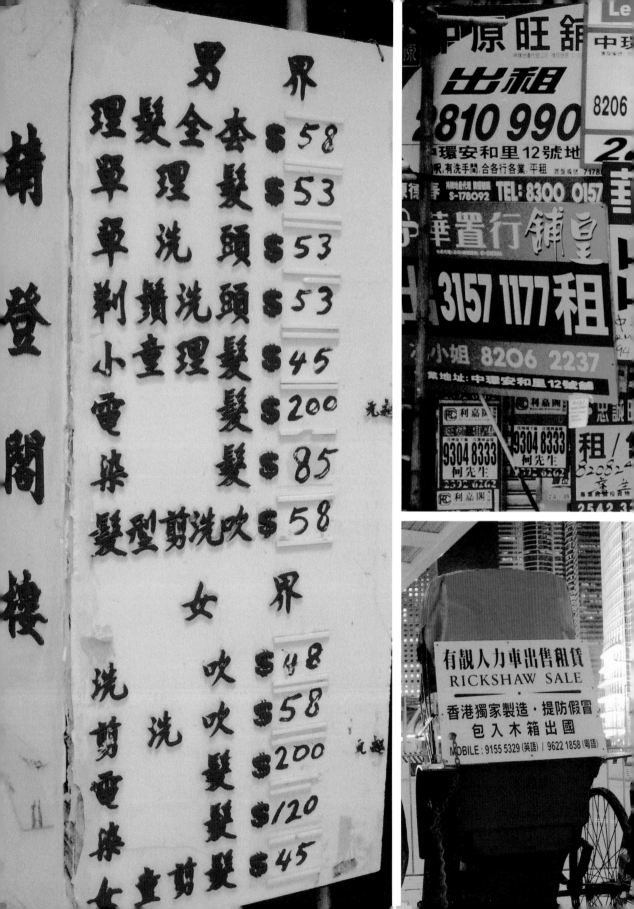

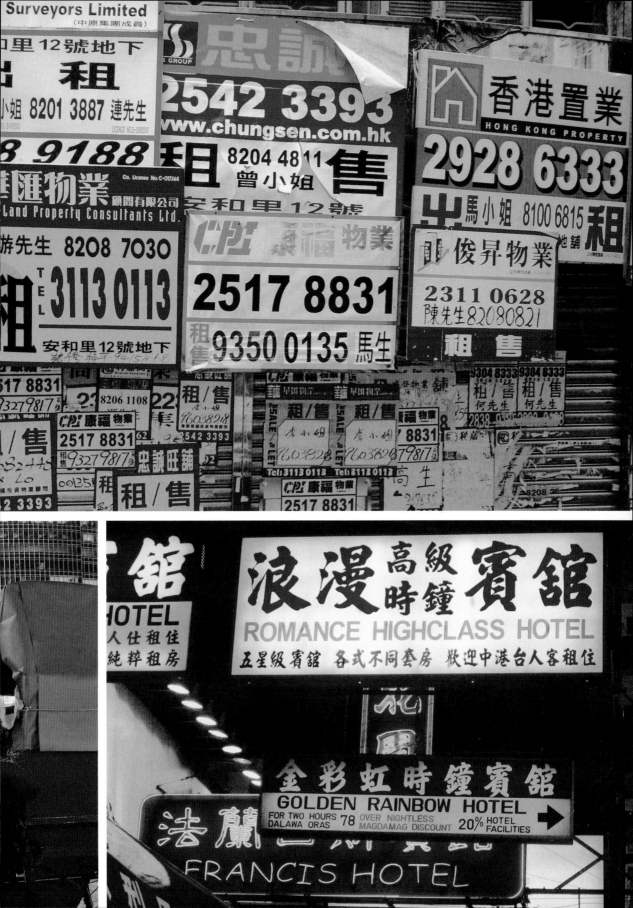

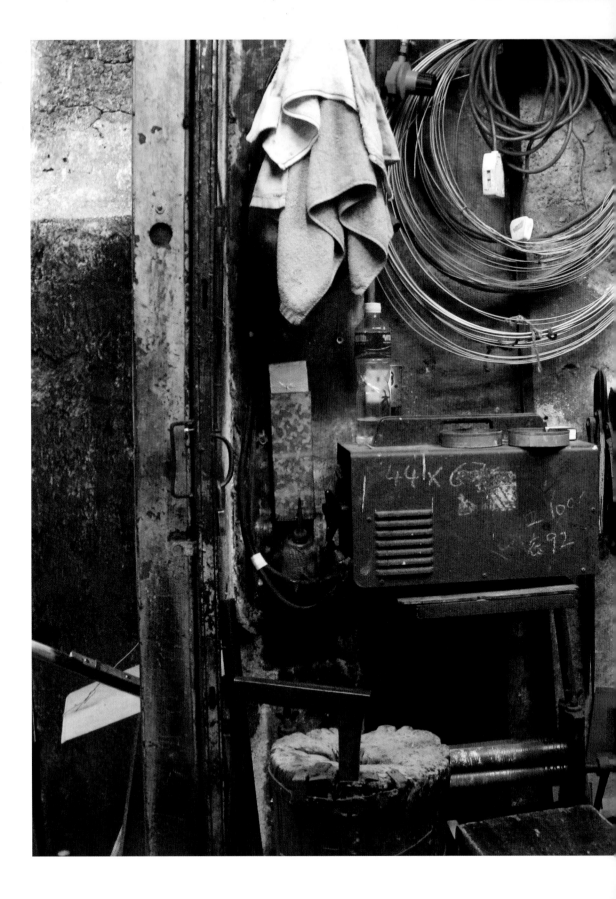

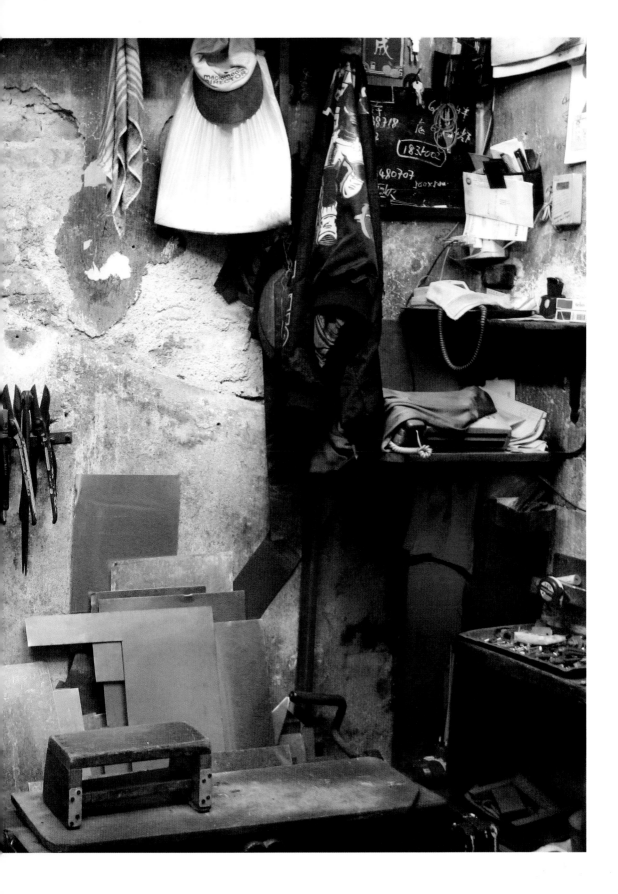

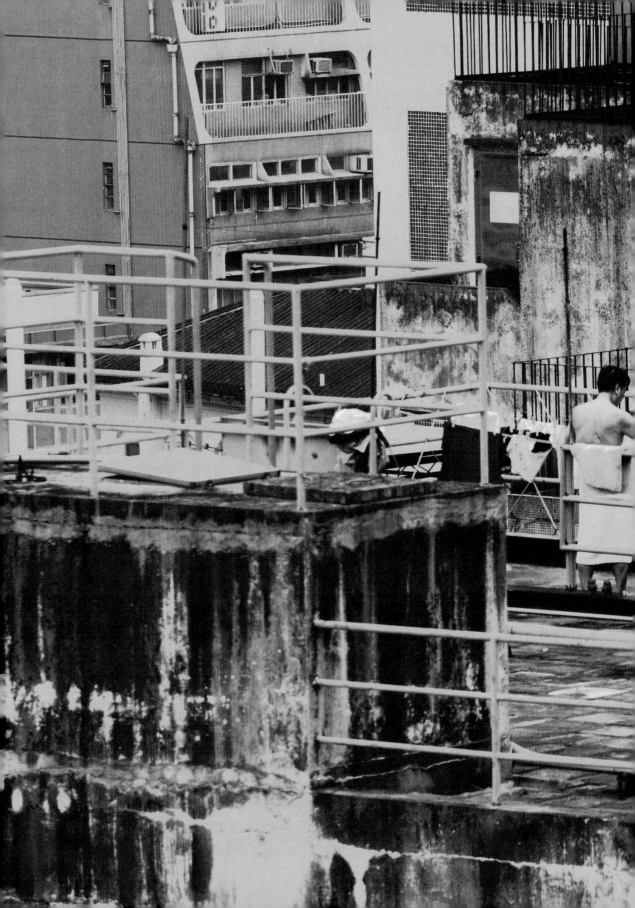

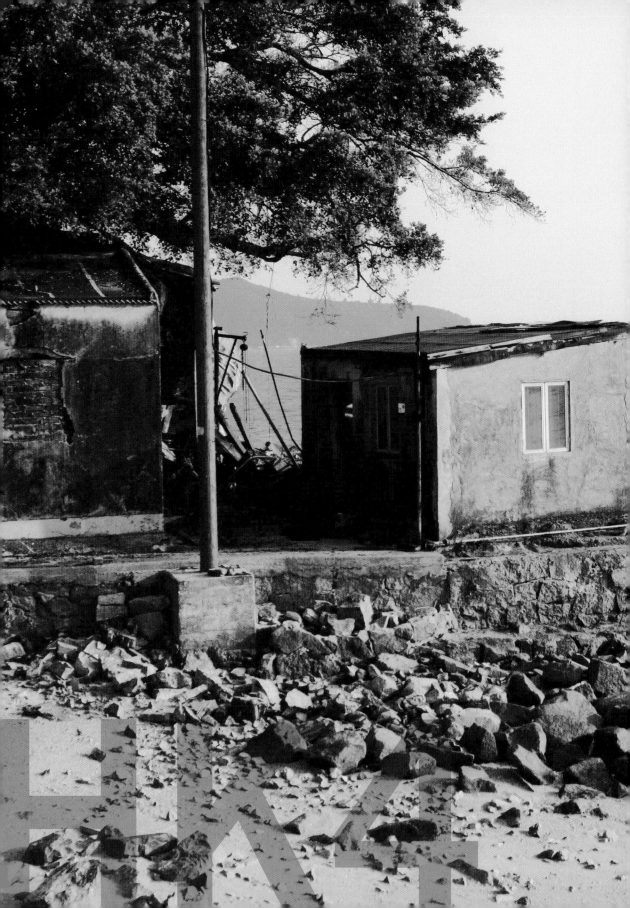

Every resident has 'their' Hong Kong. Mine was sea and salt, wood weathered by gritty sand, industrial architecture forgotten by tropical trees—a quiet retreat with fellow eccentrics at the edge of Hong Kong.

每個居民心中都有「他們自己的」香港。我的是海和鹽，被砂礫沖蝕的木頭，被熱帶樹林忘却的工業建築物 — 位在香港邊緣那個靜謐的避風港，也是稀奇古怪族聚集的地方。

Elizabeth Briel Lamma Island 南丫島

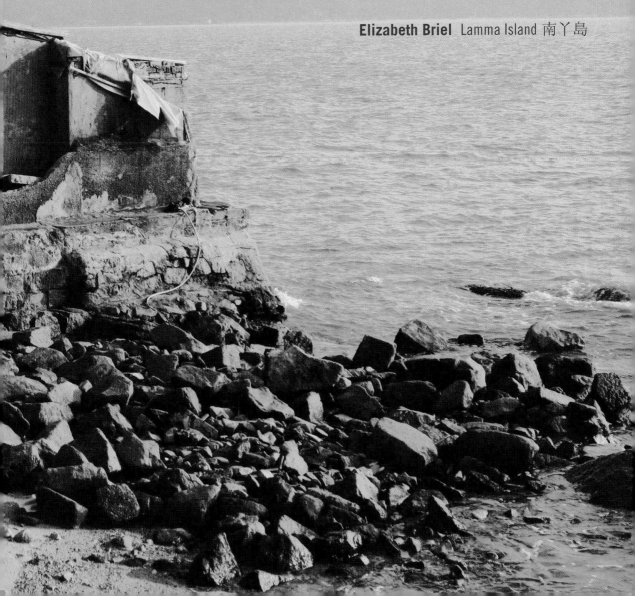

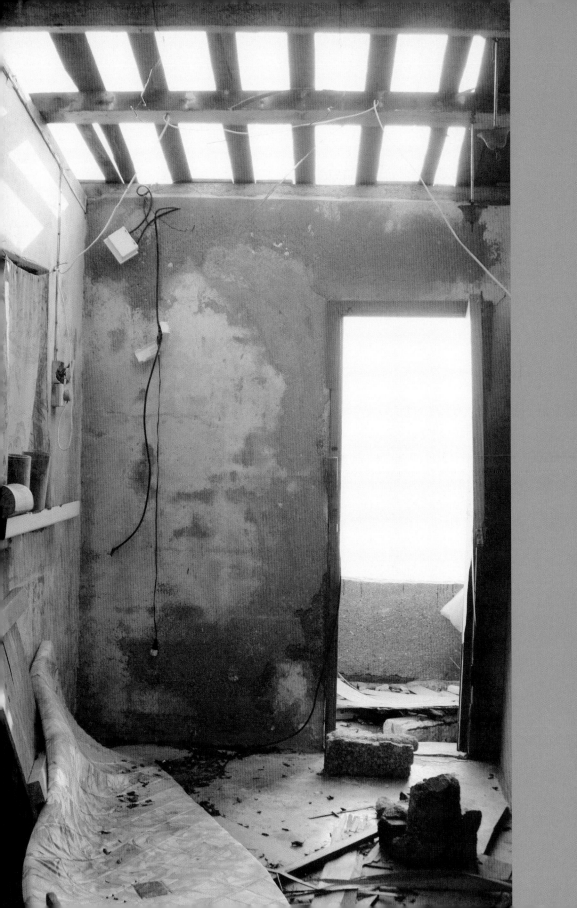

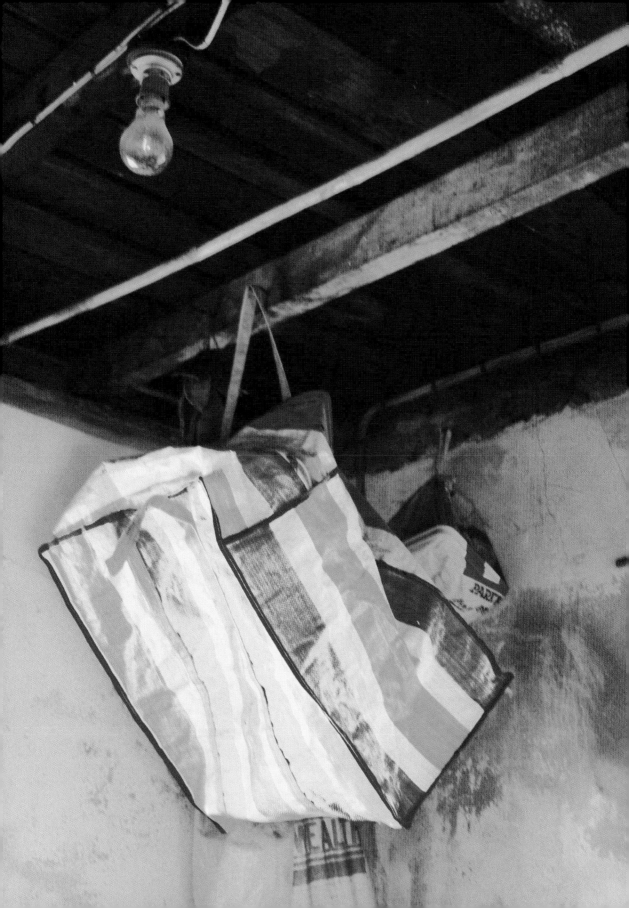

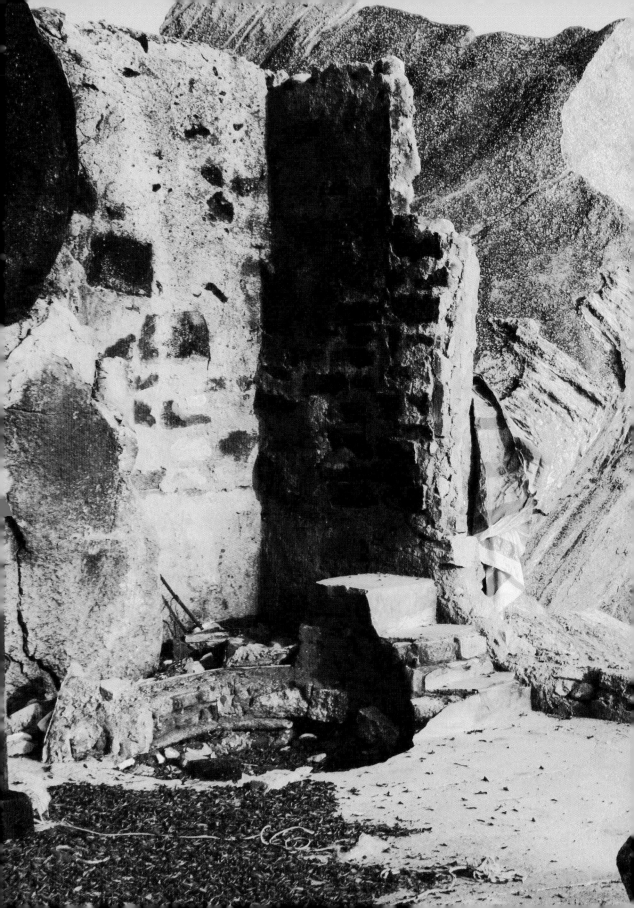

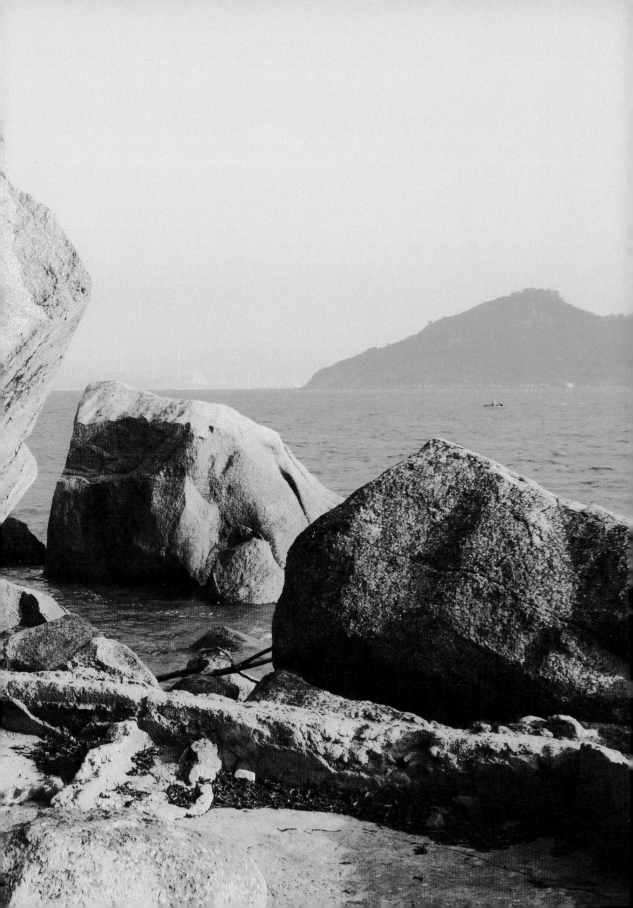

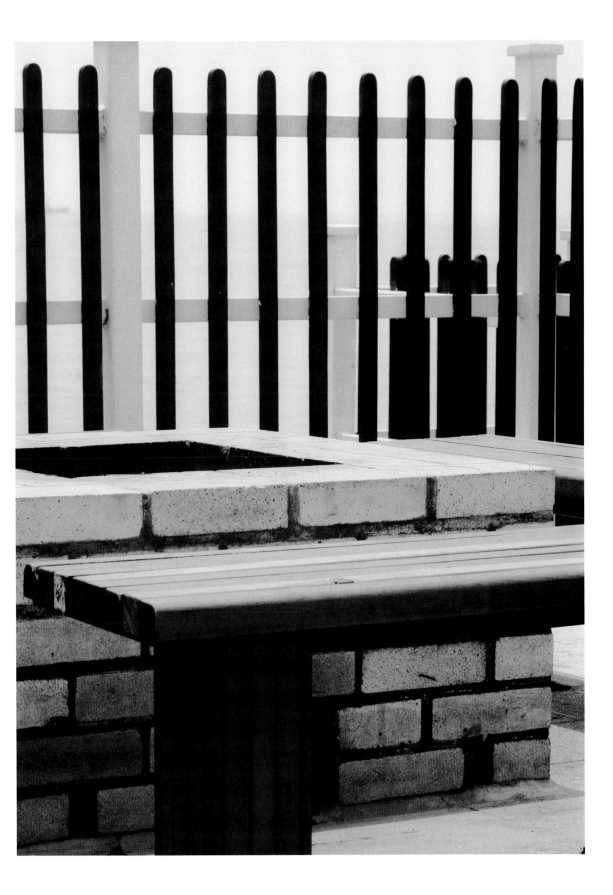

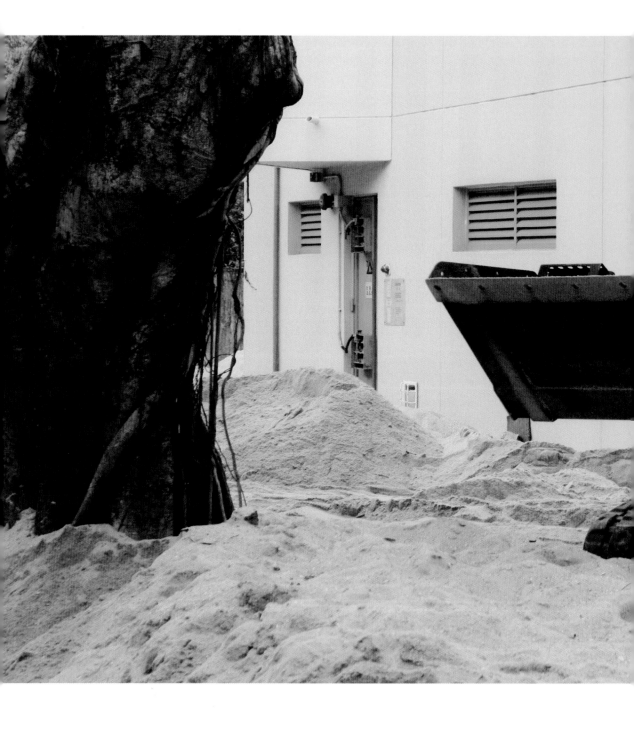

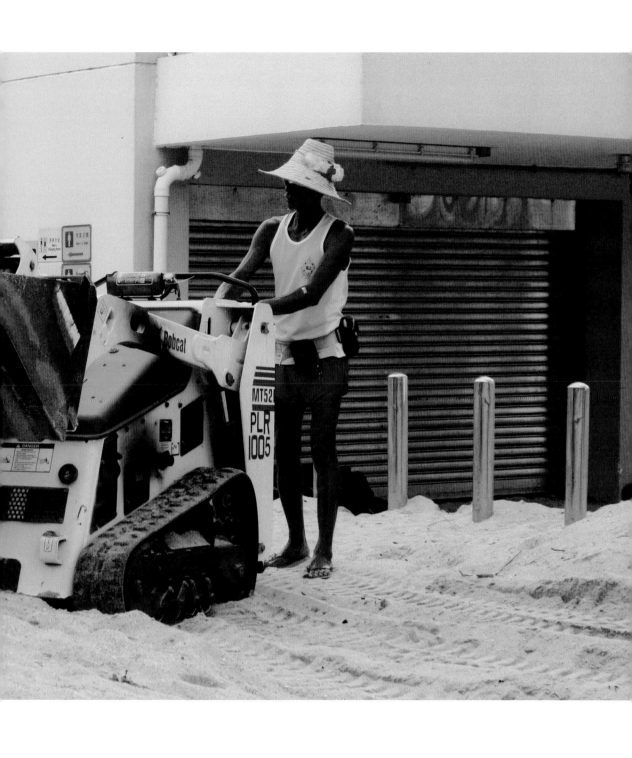

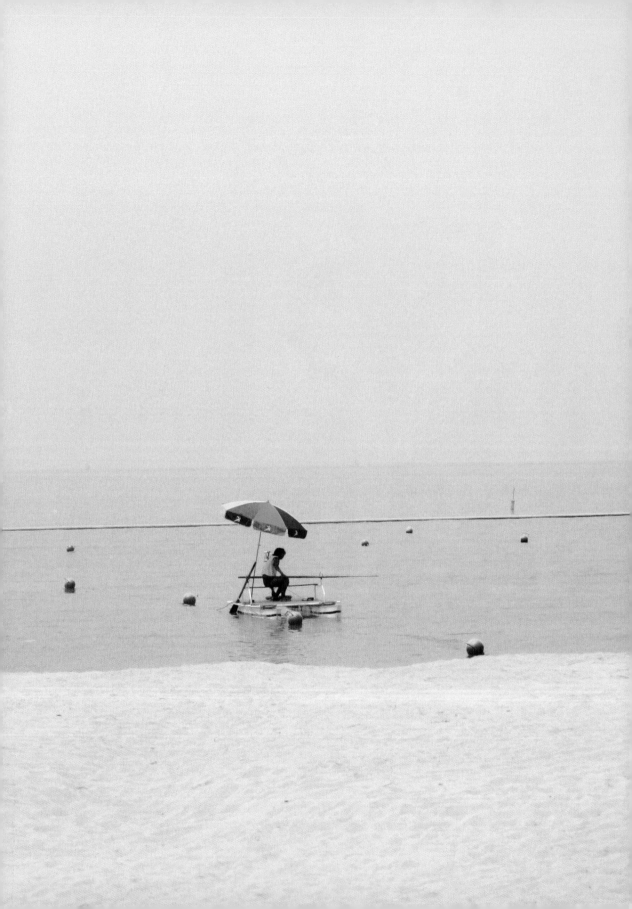

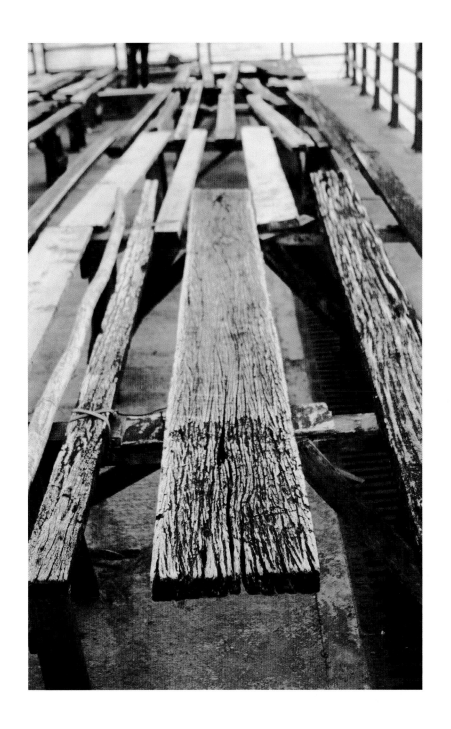

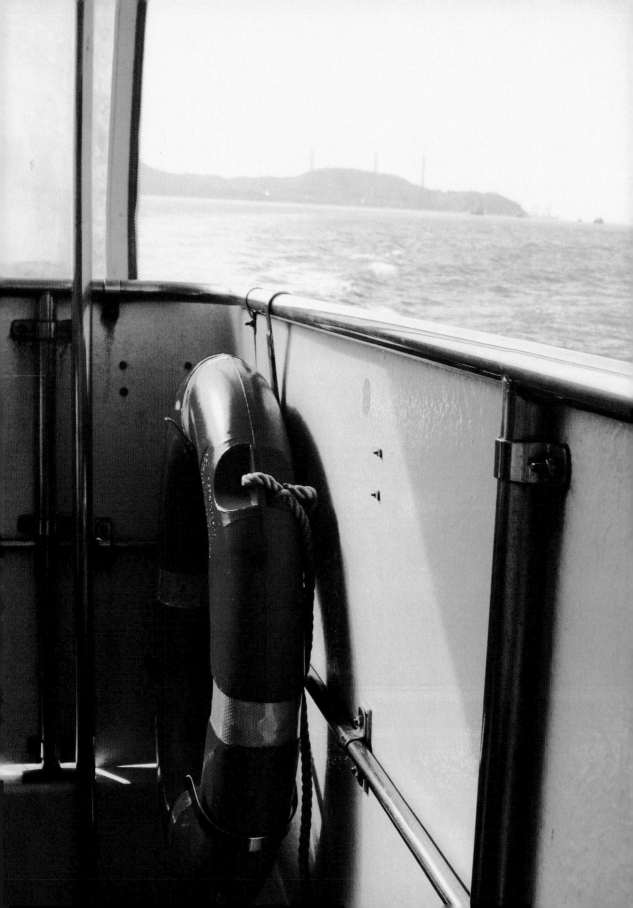

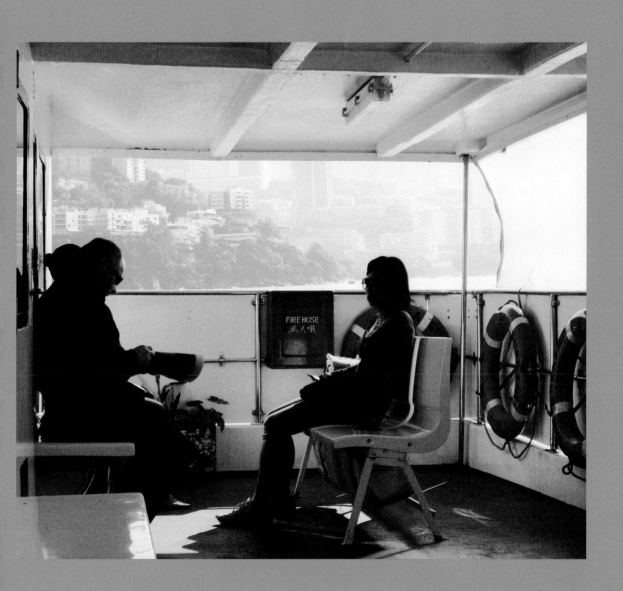

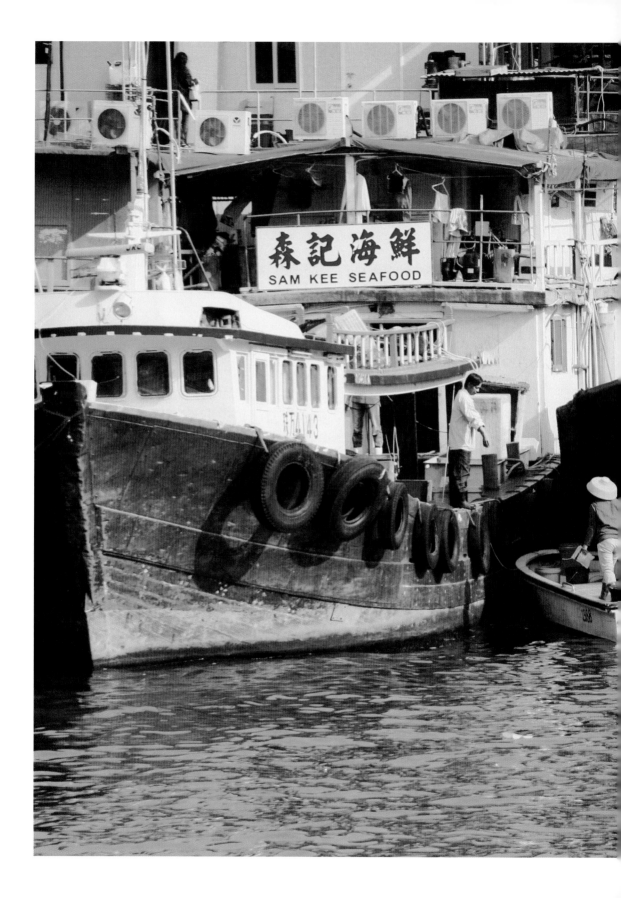

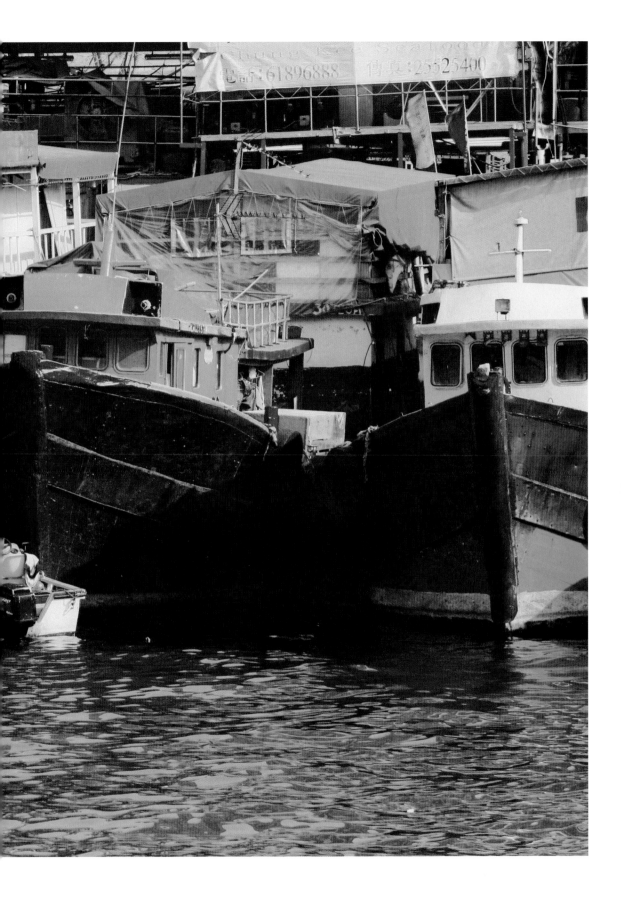

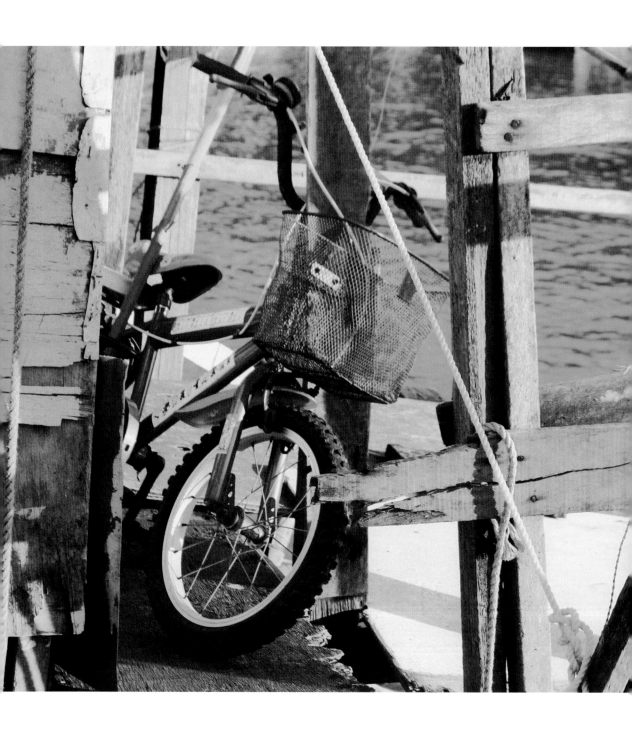

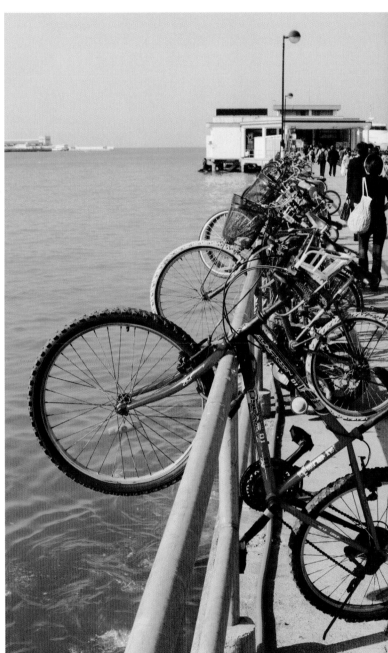

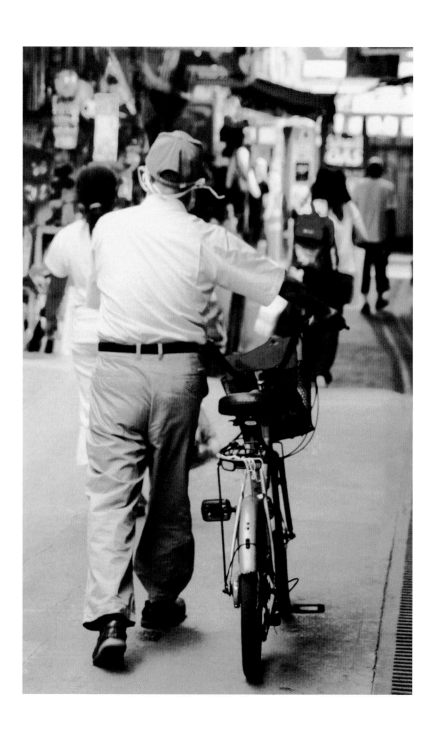

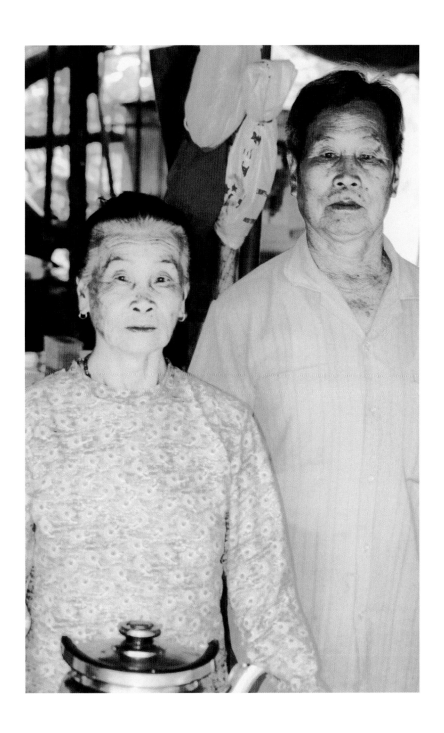

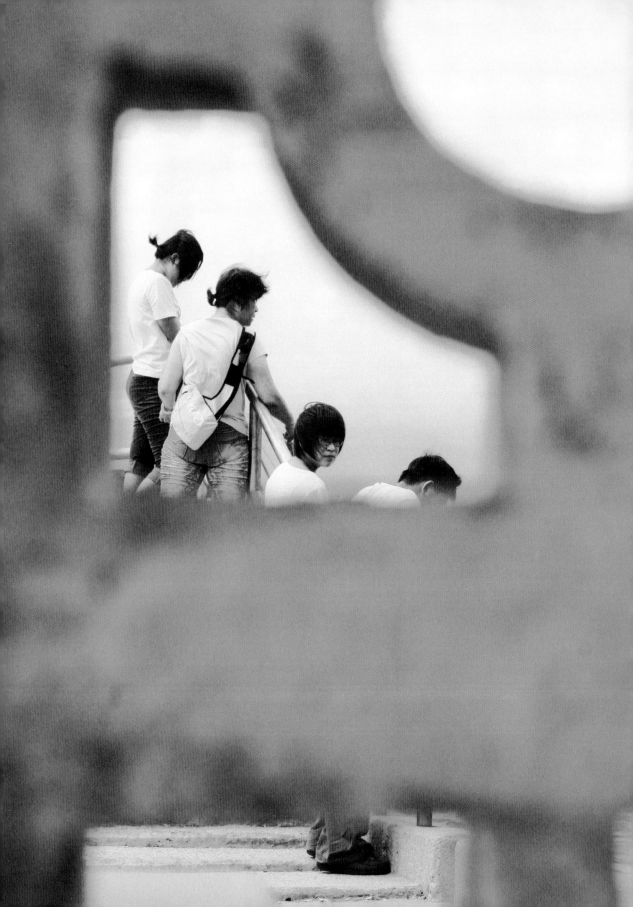

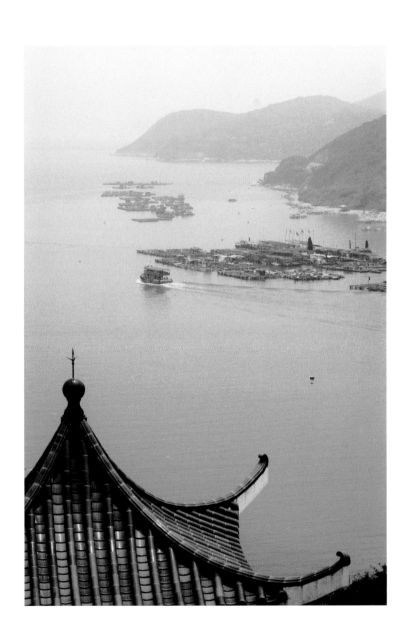

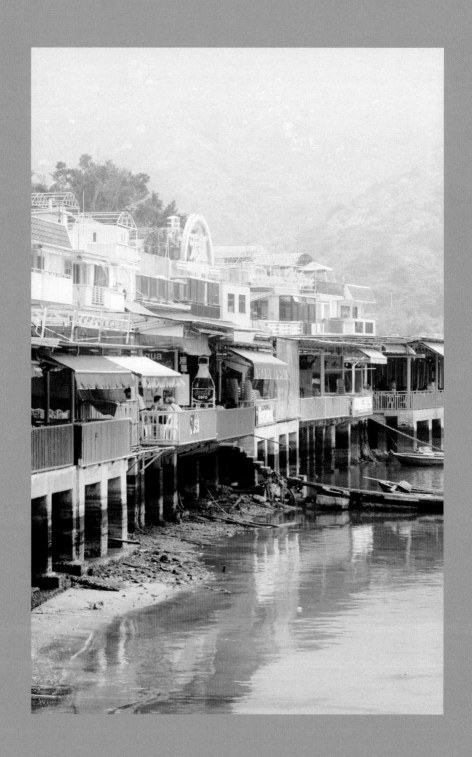

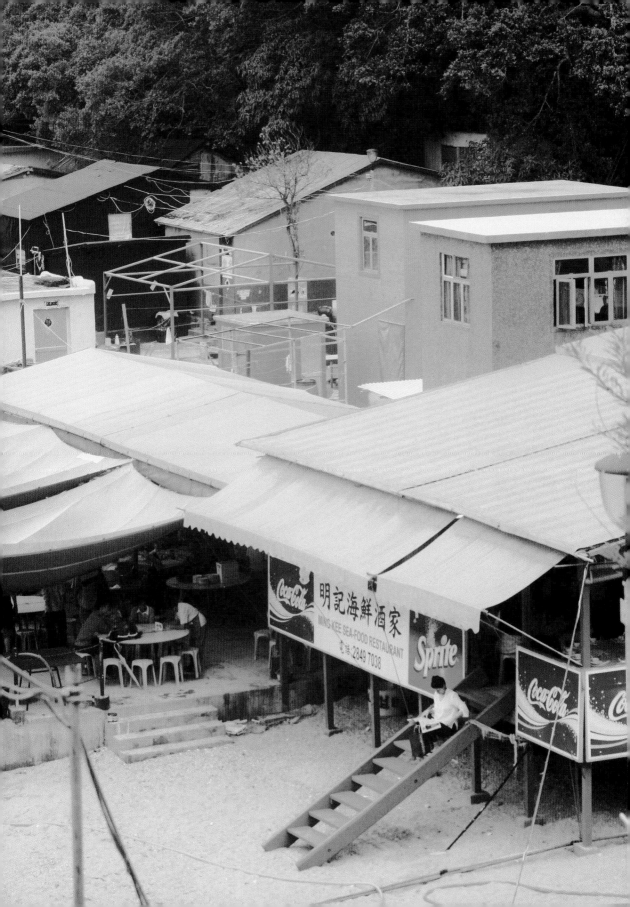

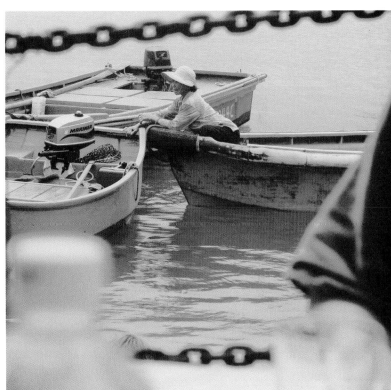

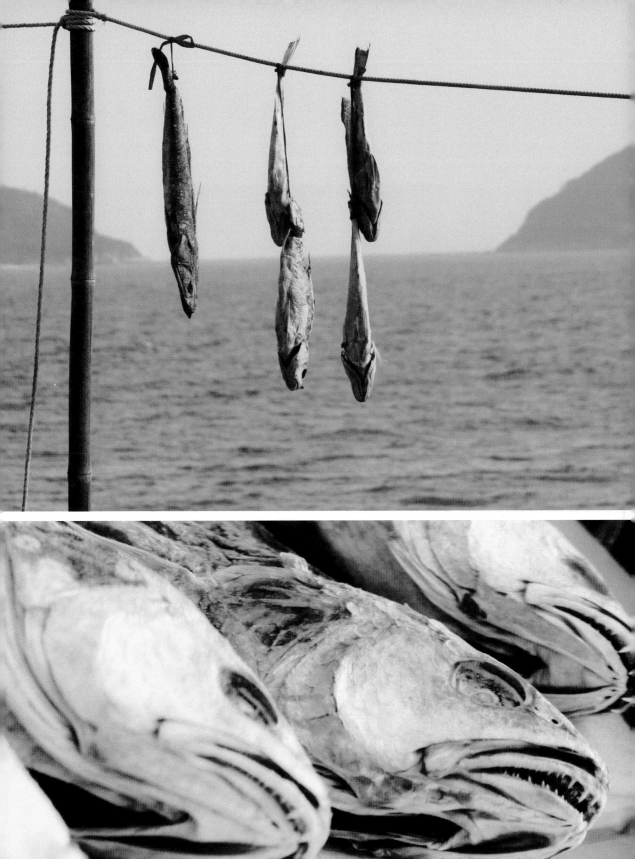

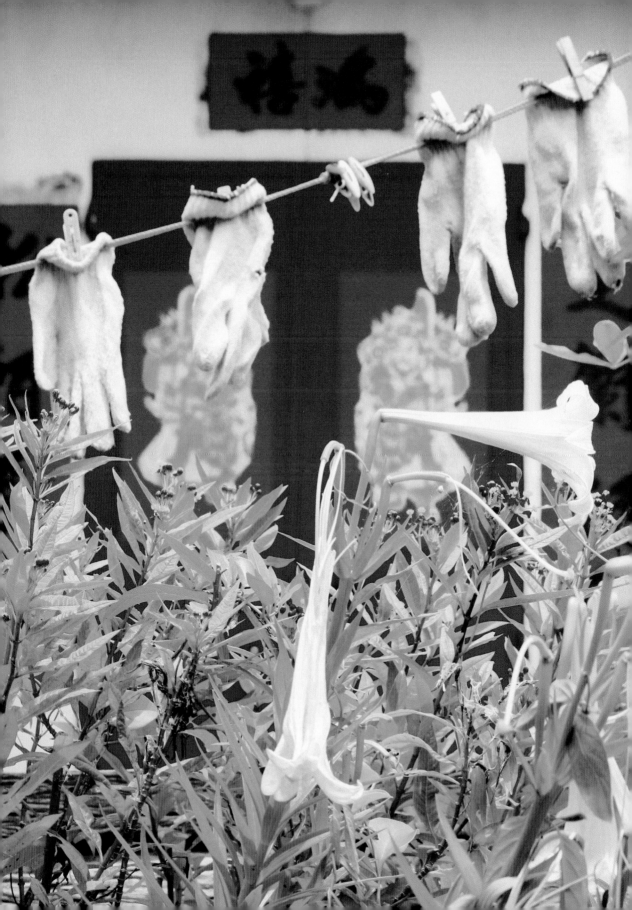

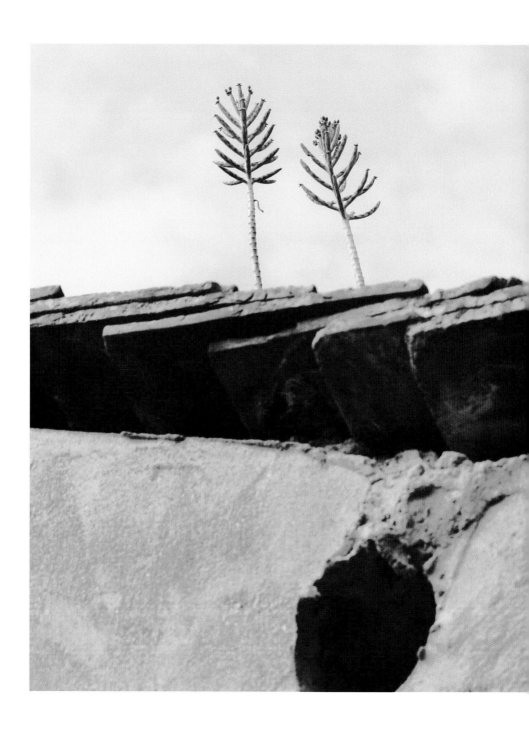

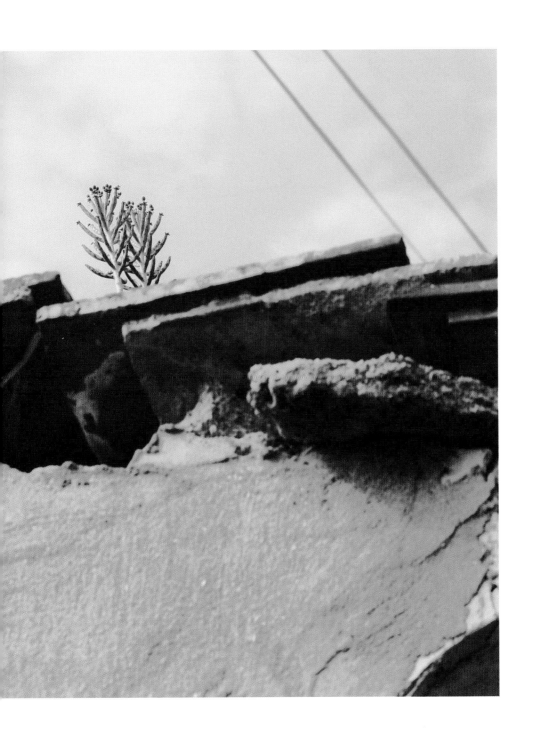

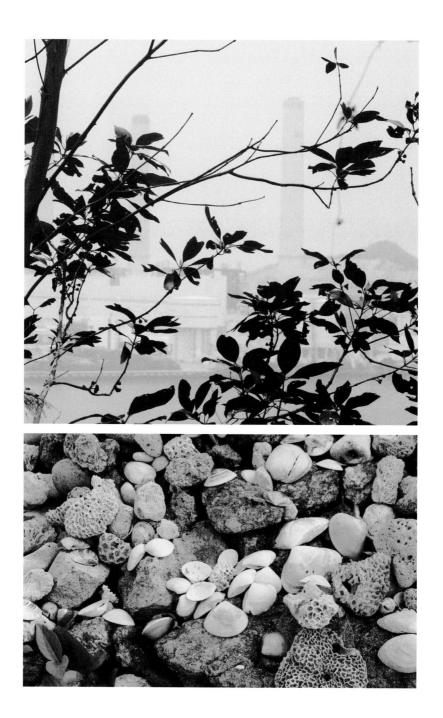

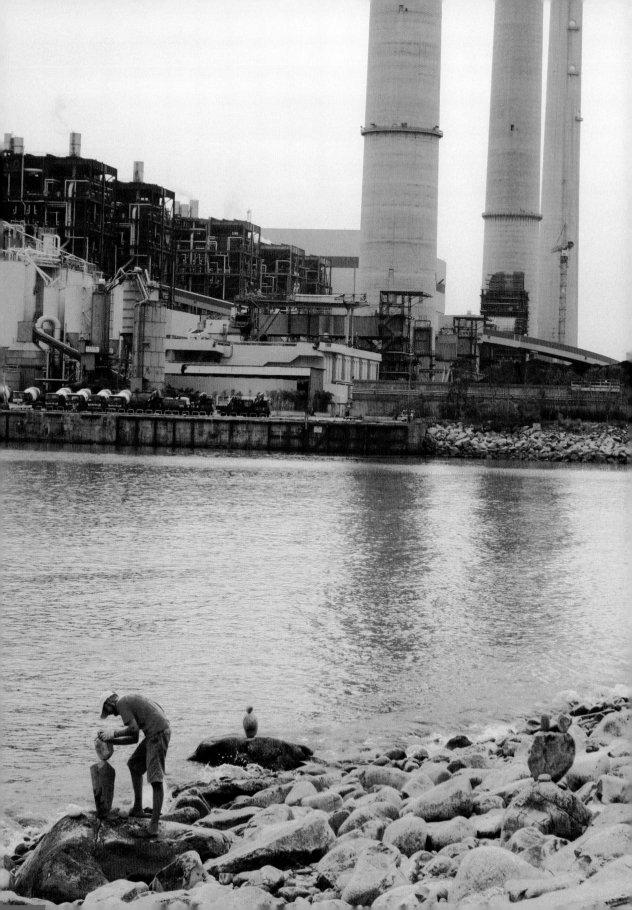

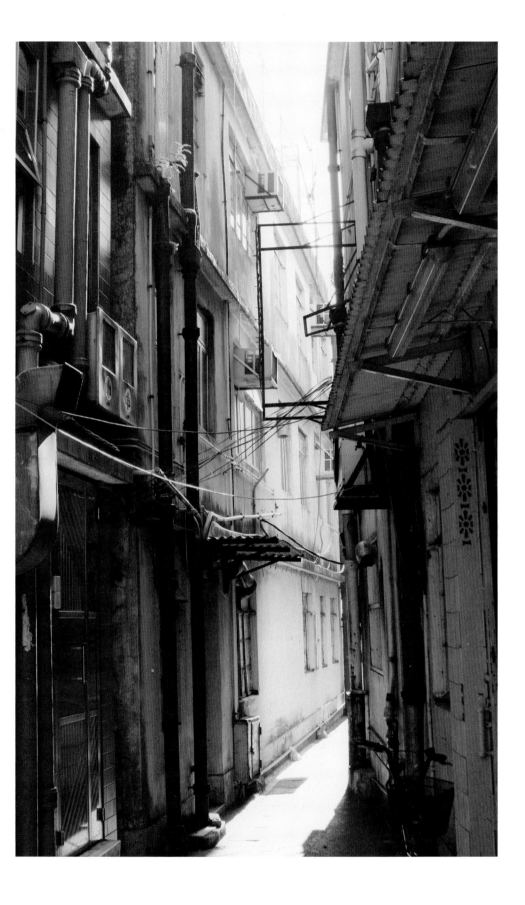

讓我在这写首詩

还记得　海水　的气味
还记得　树木　的风影
还记得　飞机　走过的　声音
忘不记　猴儿时　玩过的　小游戏
还记　蛋糕　给你的　喜欢拼图
还记得　旋转　楼梯的排列
还说得　纸皮石　後的　风光明媚
忘记日　家时码　赴出来　看天空也
那天我们说要　回到故居想你
这天我寻找　被遗忘的一句

却
令忘记

2014 11月29日

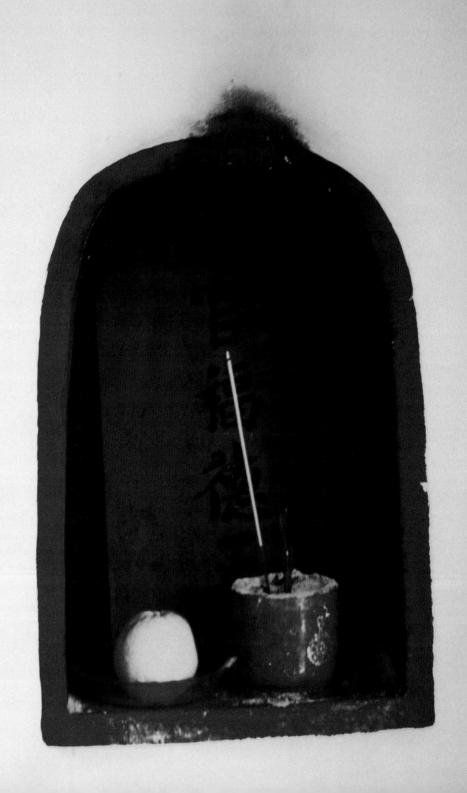

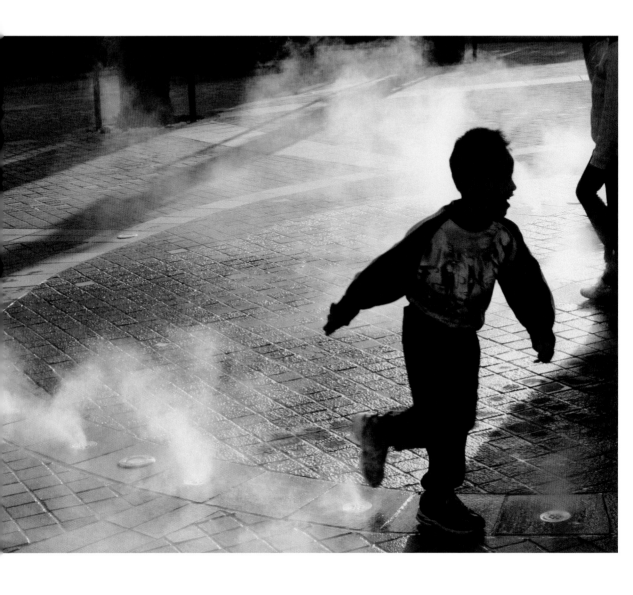

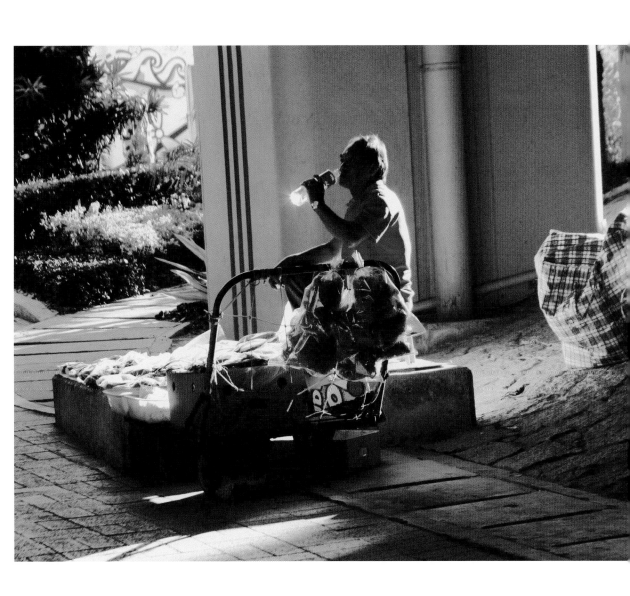

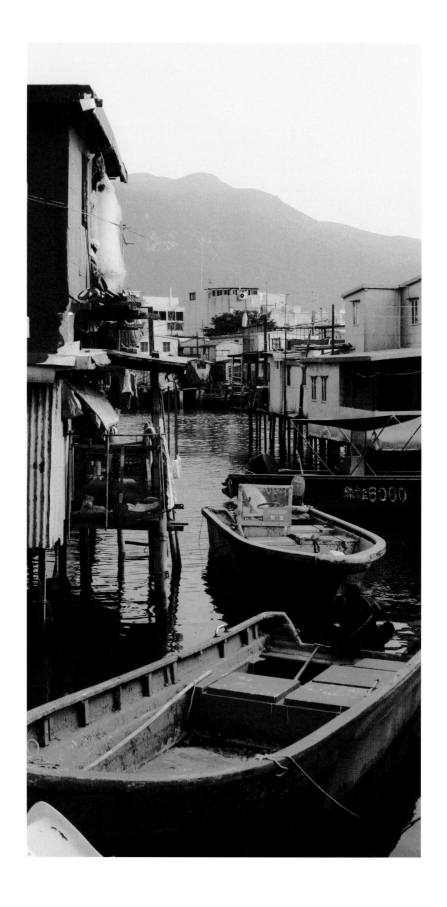

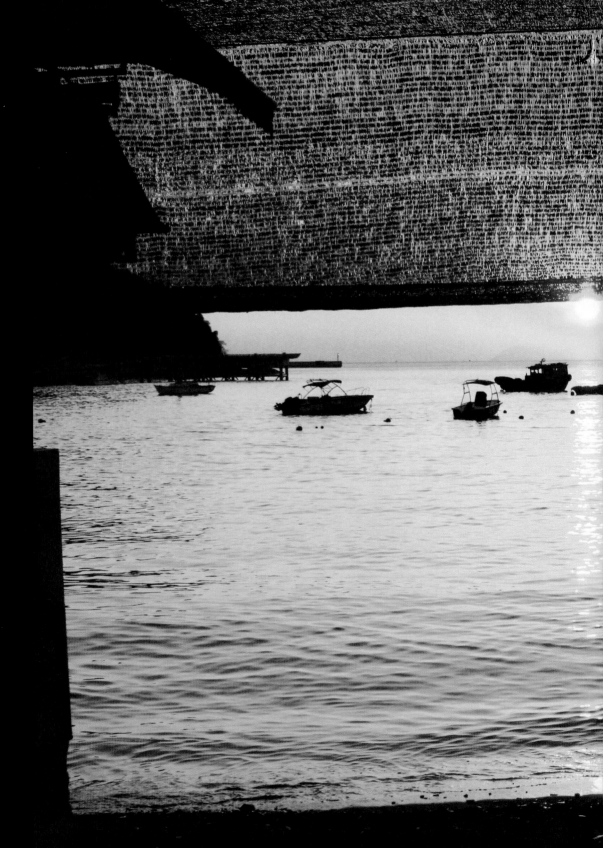

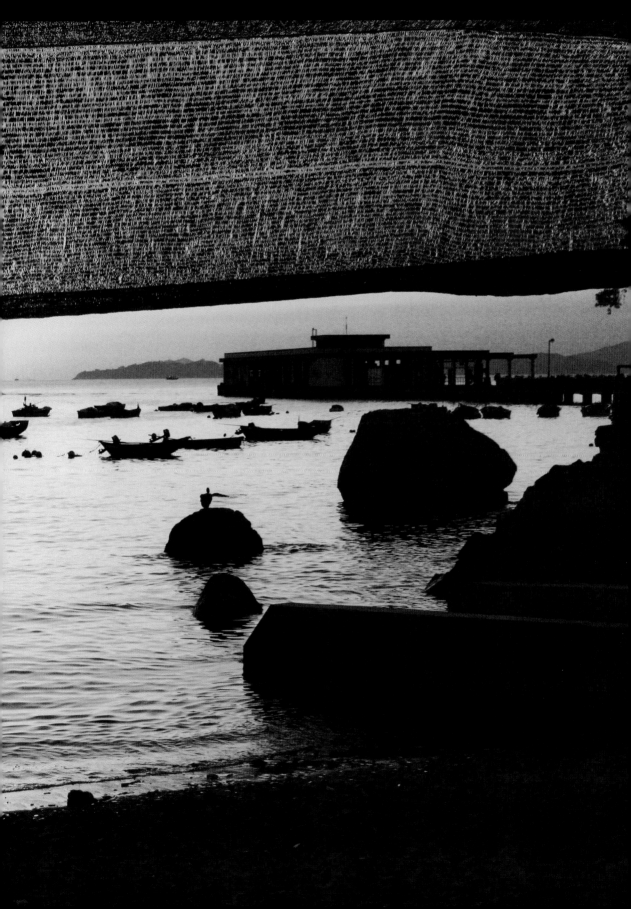

Industrial Hong Kong echoes Nature.
And a city reveals its secrets upon
focused and sustained observation.

高度工業化的香港和樸實的大自然相呼應。透過持續地對焦和不斷地觀察，這個城市掀開了它神秘的面紗。

Li Sui Pong Pok Fu Lam 薄扶林

HK5

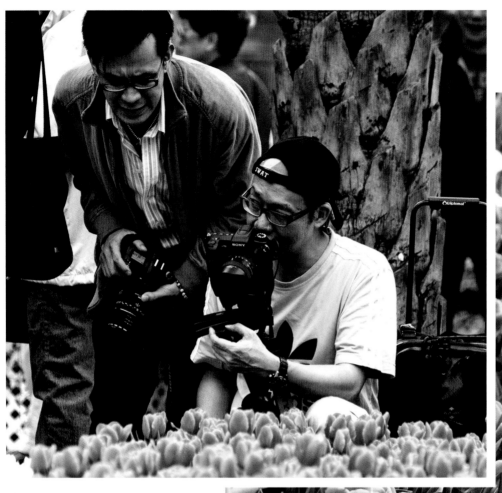

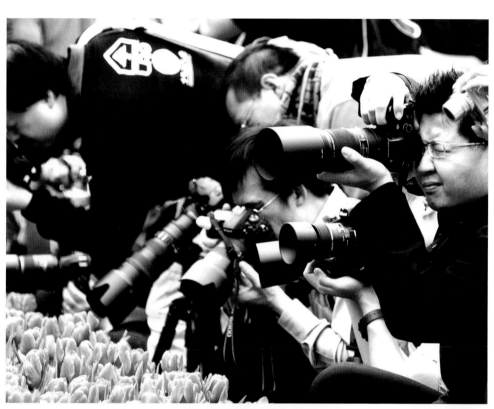

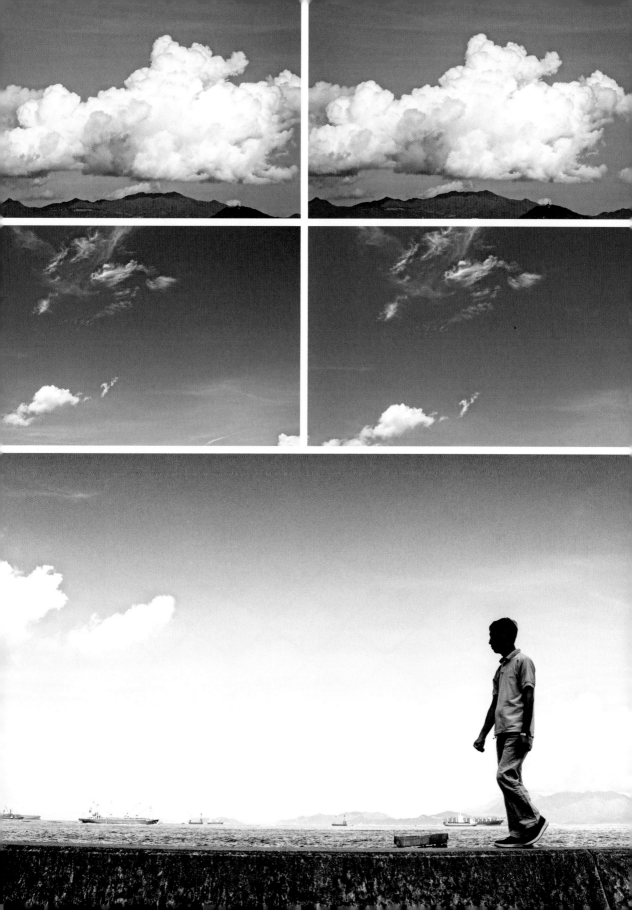

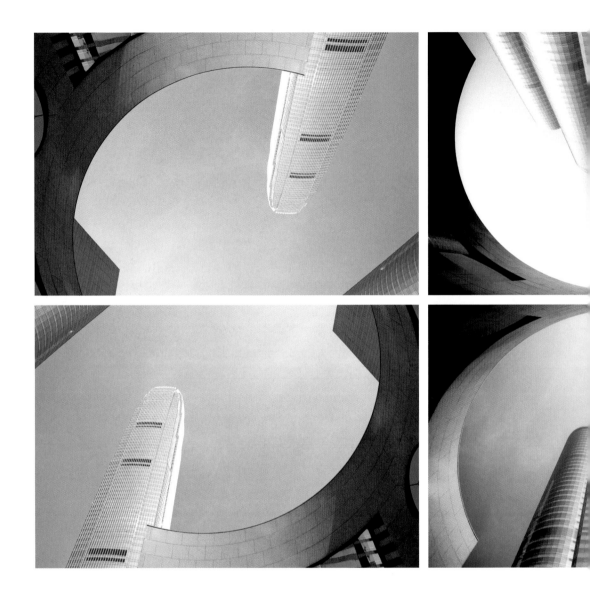

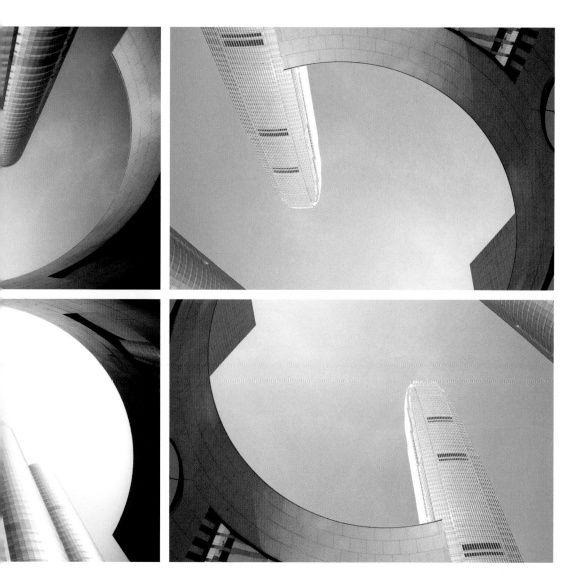

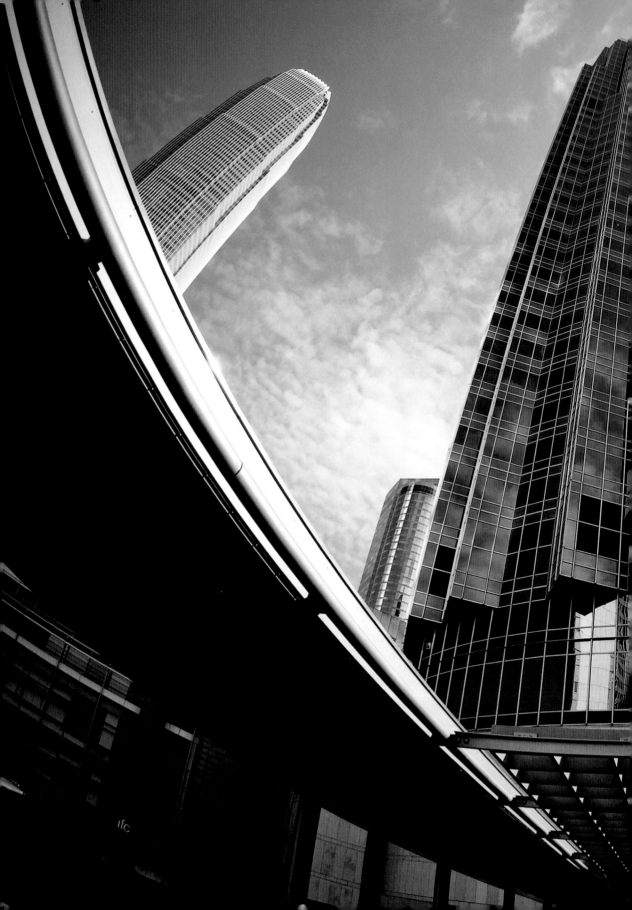

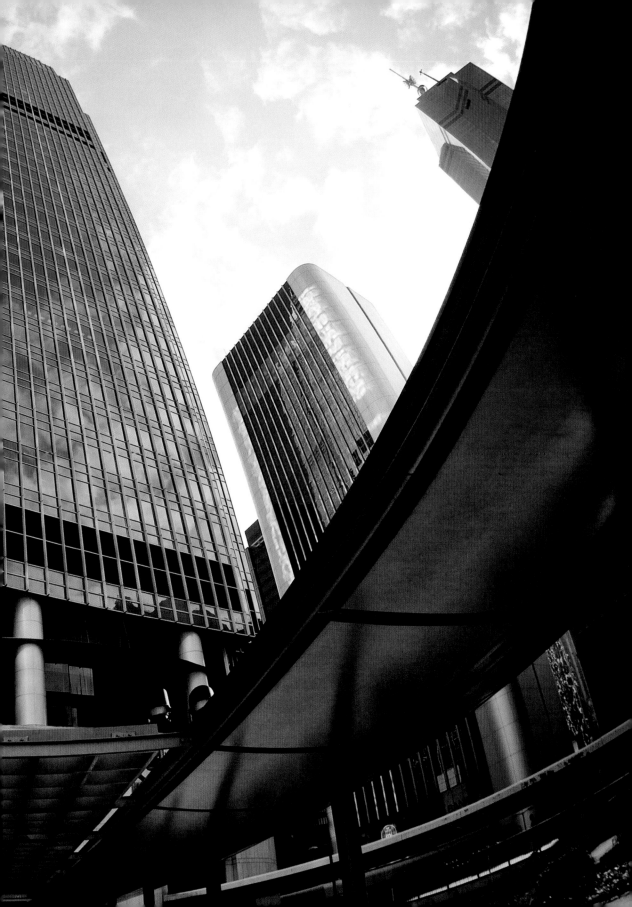

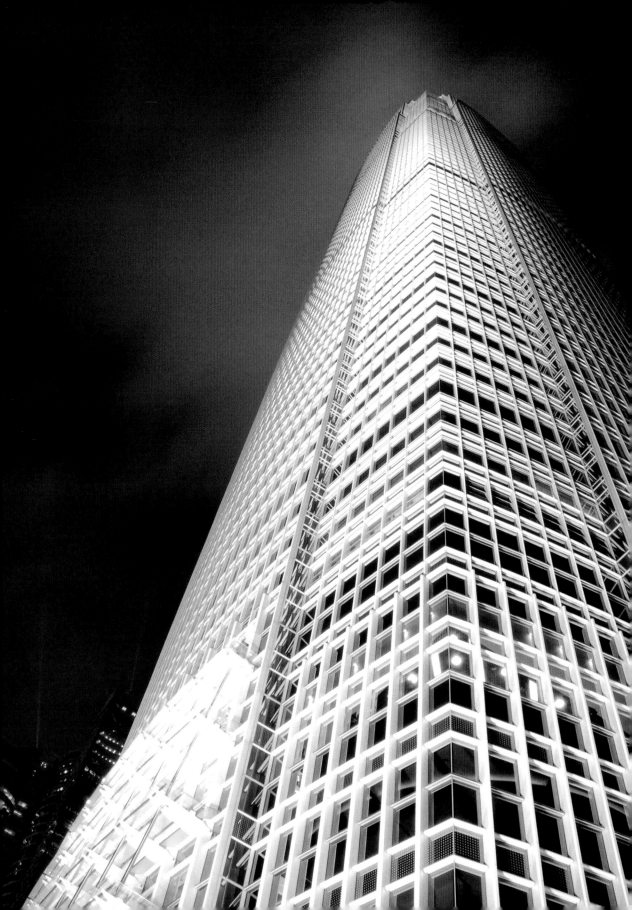

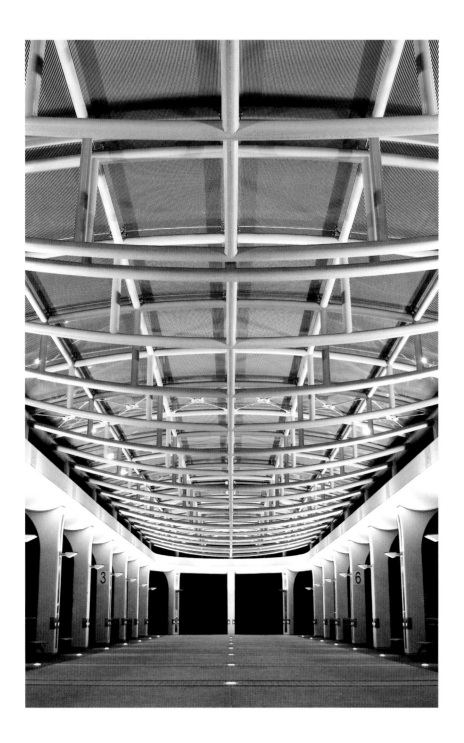

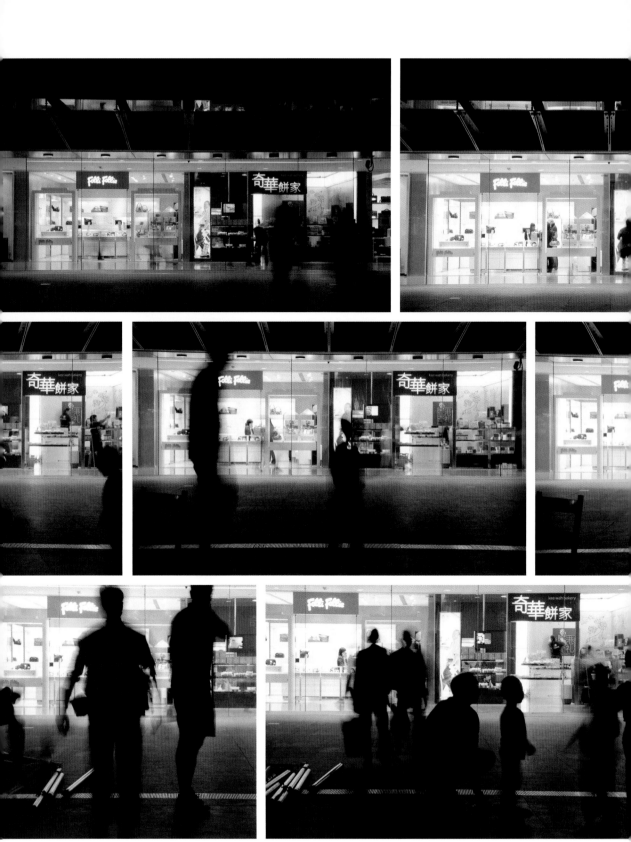

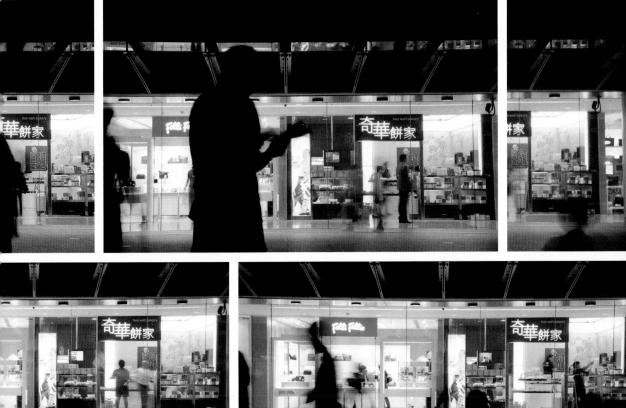
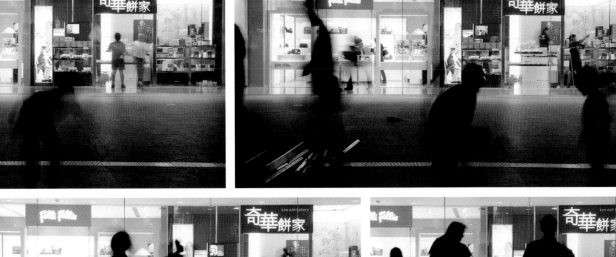
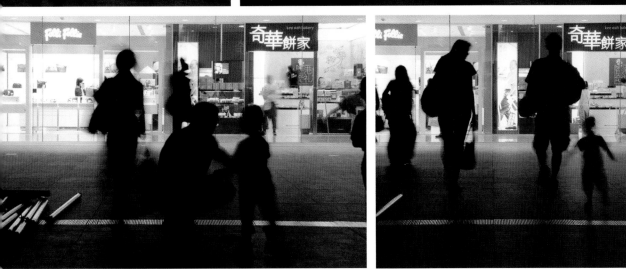

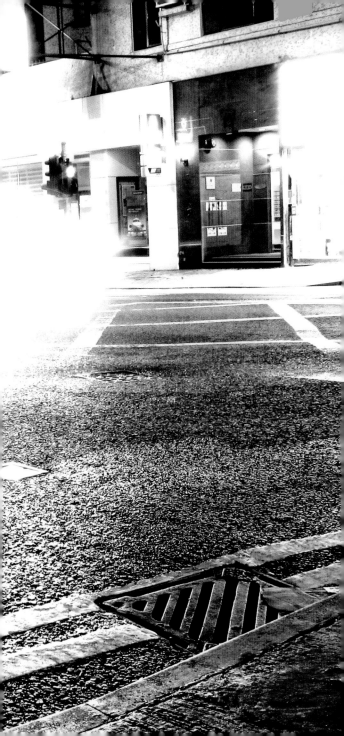

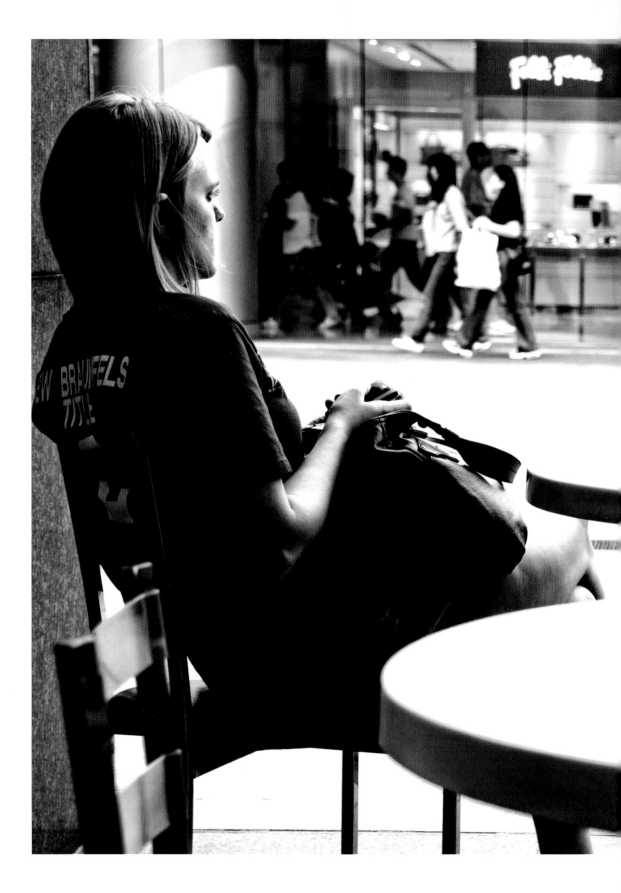

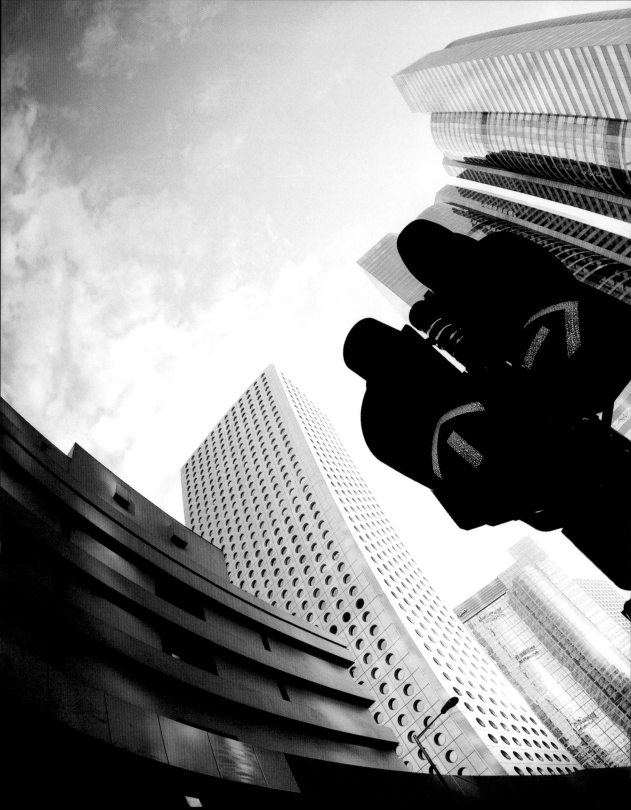

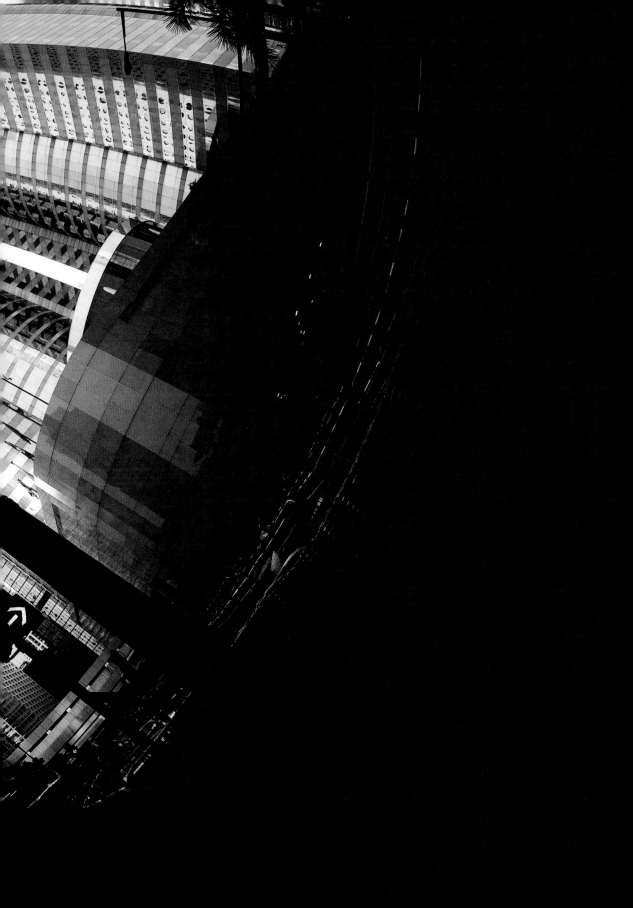

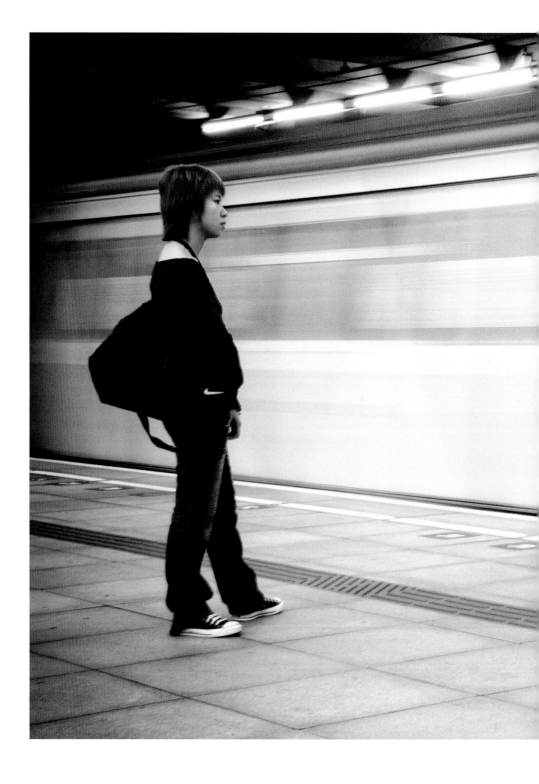

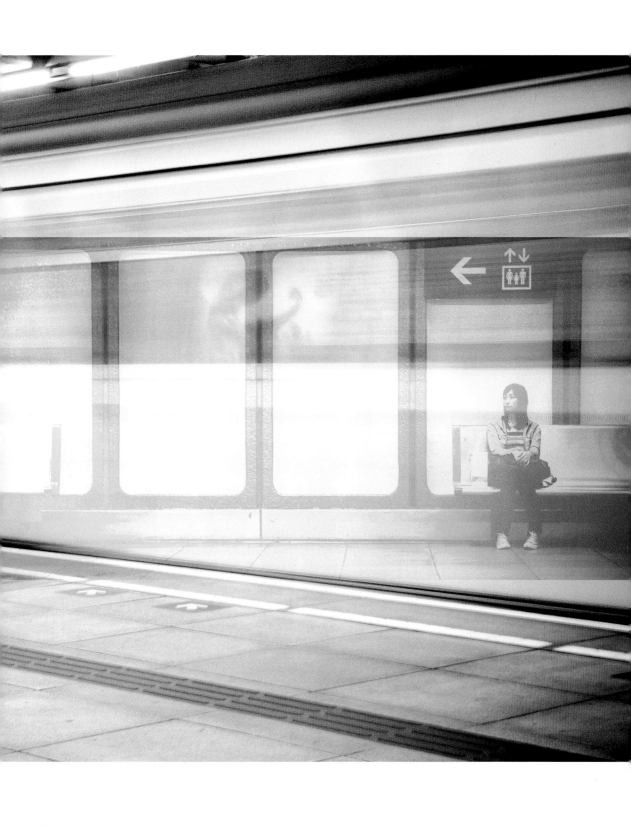

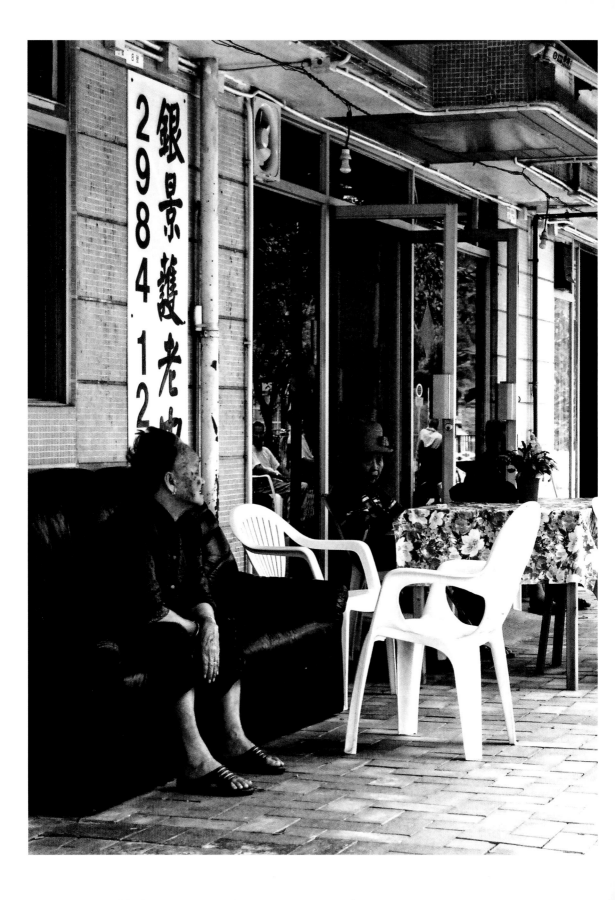

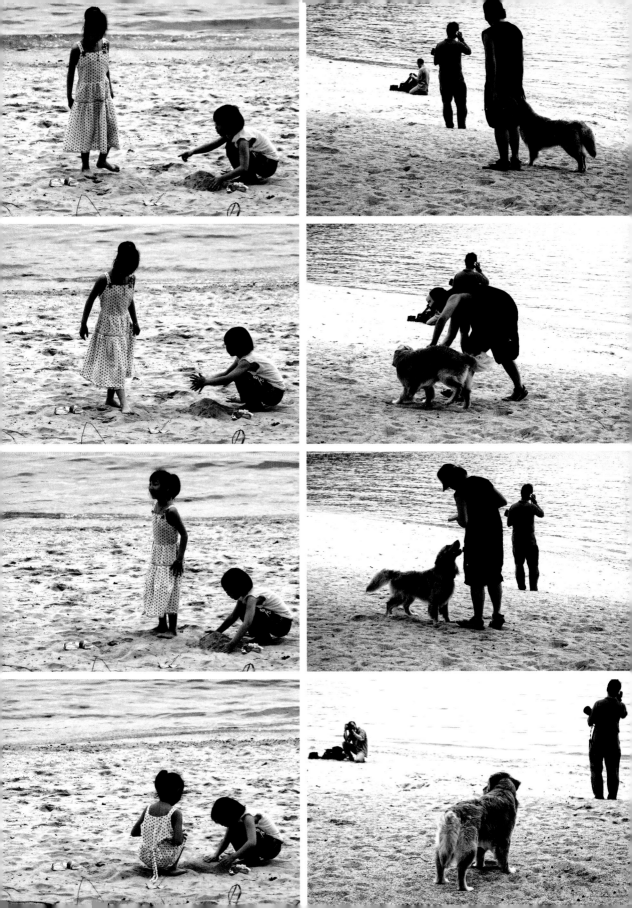

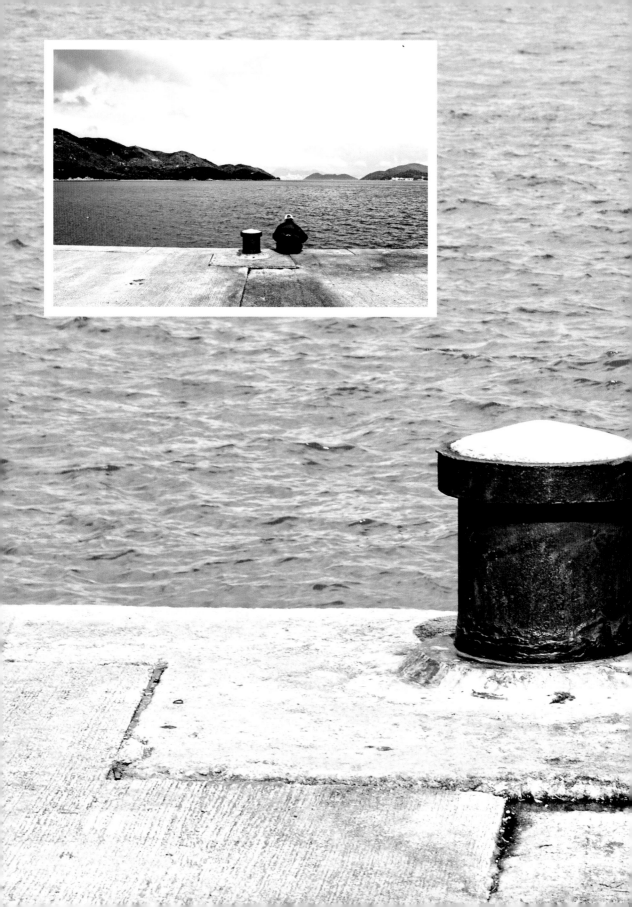

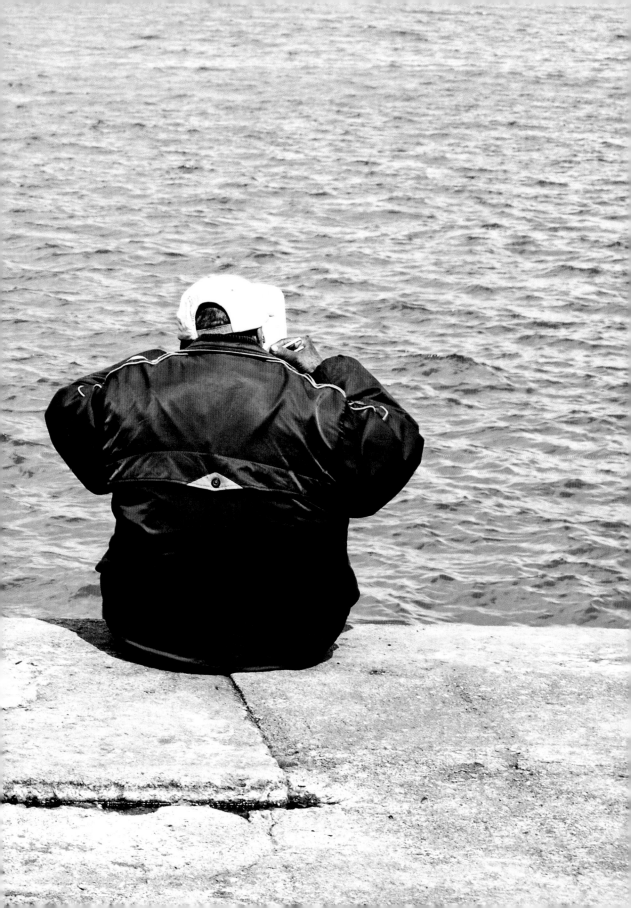

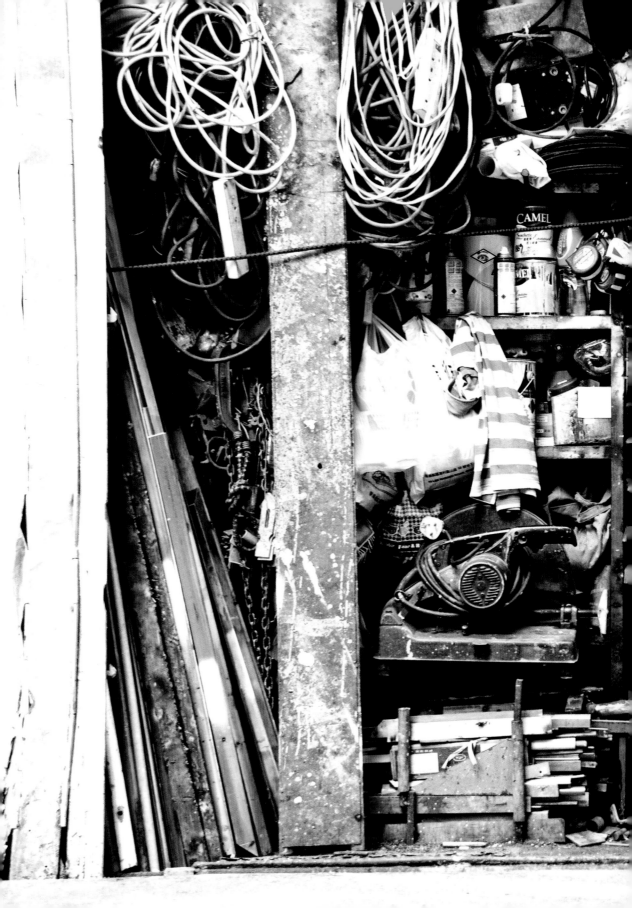

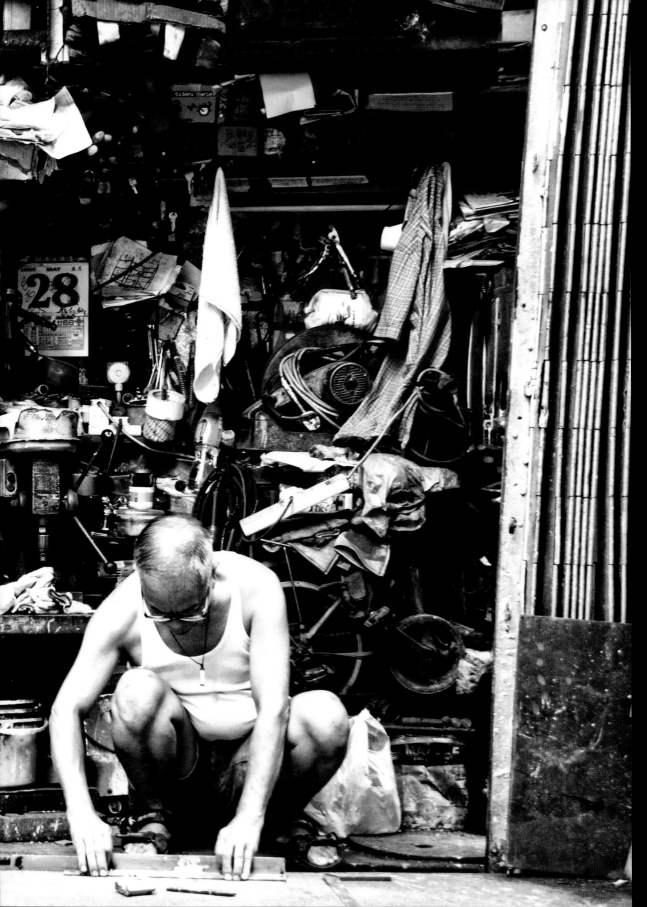

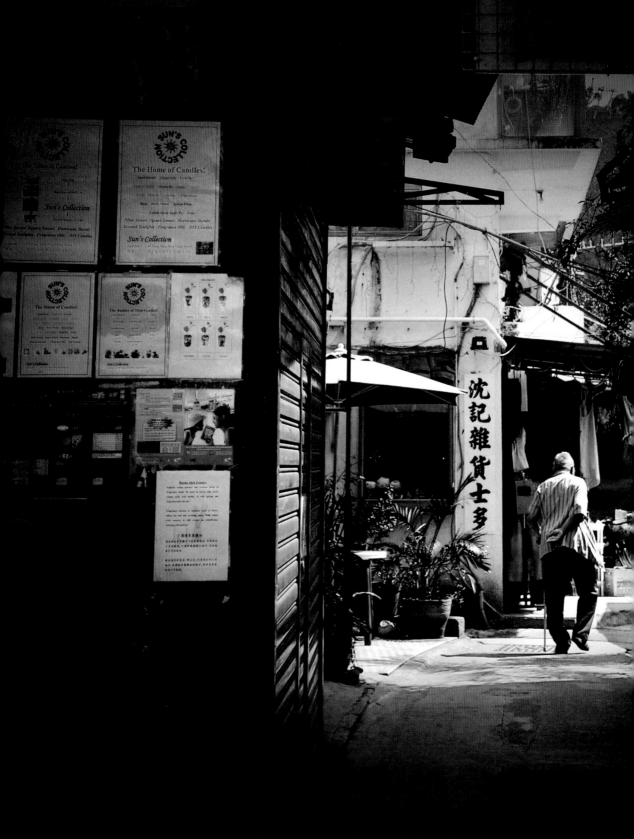

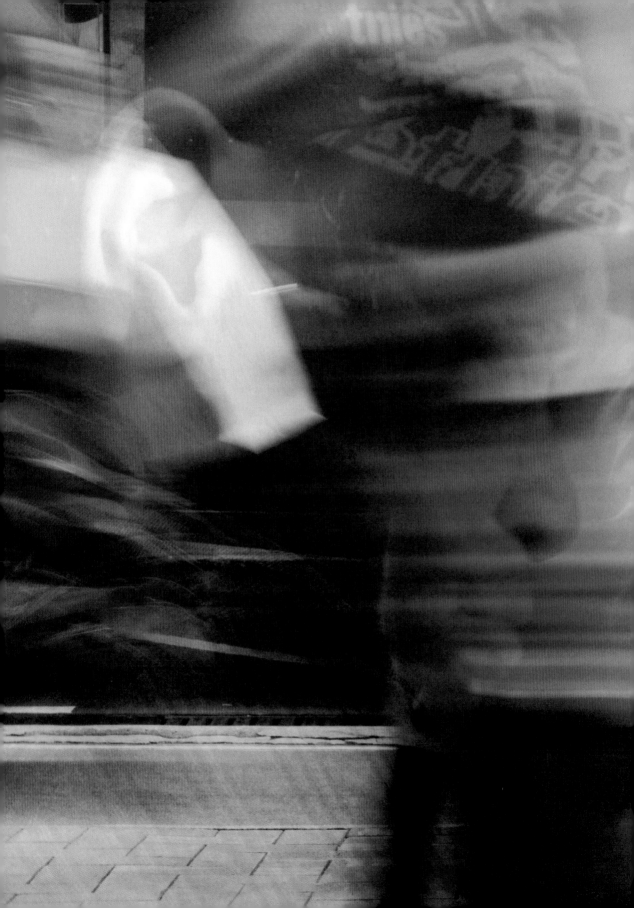

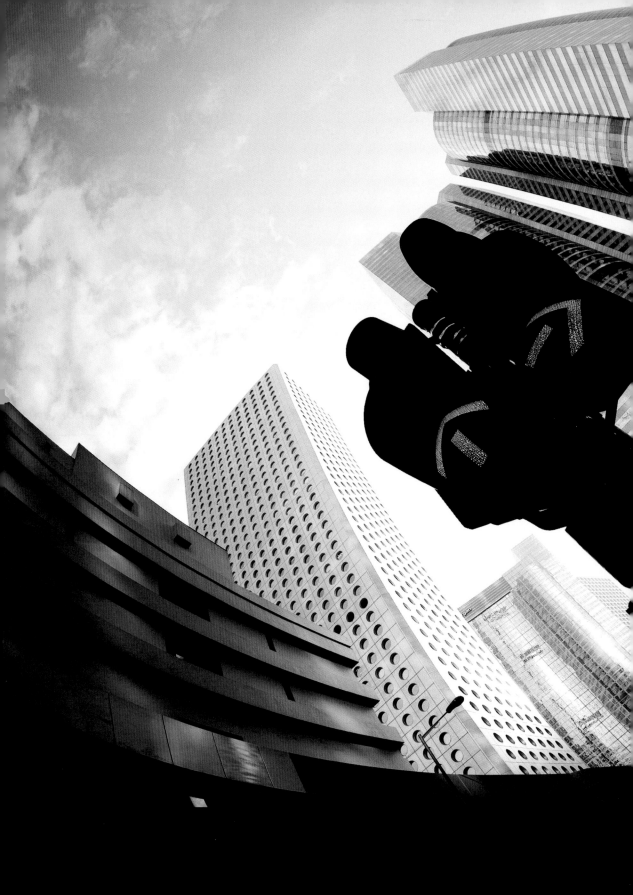

ACKNOWLEDGMENTS

Albert--for your encouragement and support over the years // HK City Dwellers: Hank, Albert, Blair, Elizabeth, and Kit--for your unique perspectives and insights into HK // Michelle--for your help in translation // Janet B.--for your editorial help and insights into the publishing world // Hank--for letting me crash at your place, taking us around and letting us observe a true HK city dweller first-hand, and trekking up Dai Mo Shan with us // James--for the brainstorming session at Chow that motivated me to get this project started // Chi-Ming--for your partnership at Dayspring and for always helping me to communicate what I want to say // Jeff--for your editorial help and encouragement // My family in HK --for the inspiration you gave me for this book by sharing your lives with us // 媽媽 -- 愛玩，冒險精神，和天生的好奇心，是您給我最好的禮物。// Redeemer Community Church--for your constant love and support // Ed--for your love and patience through everything.

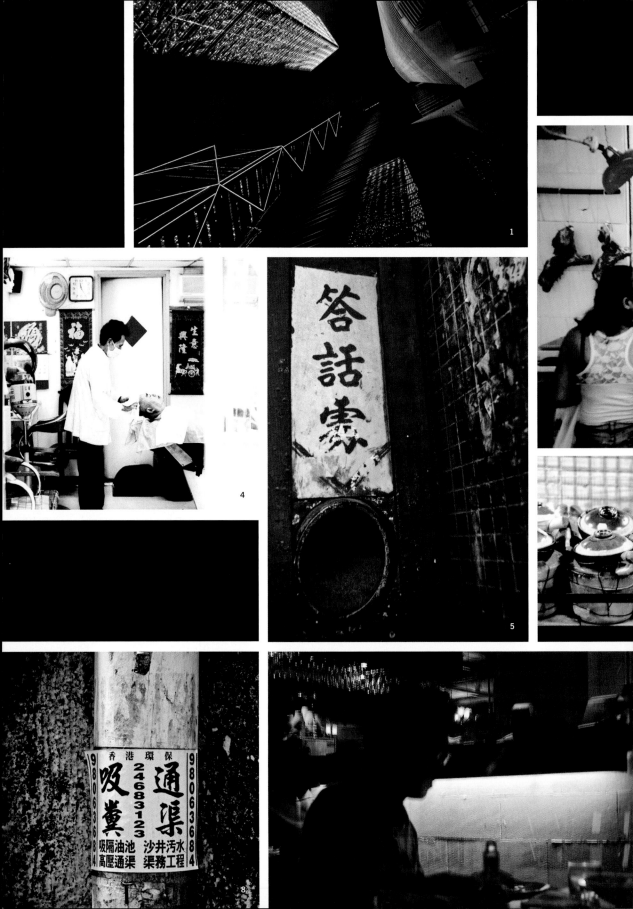

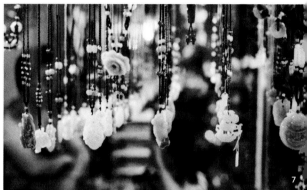

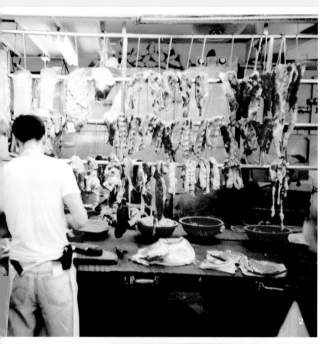

Hank Leung
Hunghom 紅磡
Lawyer
flickr.com/photos/hleung/

1. Skyscrapers in Central (Clockwise from top left: Cheung Kong Centre, Citigroup, ICBC, and Bank of China)
2. Butcher shop on Graham Street in SOHO, Central
3. Fence in Shum Shui Po
4. Barbershop in Shum Shui Po
5. Apartment intercom in Shum Shui Po
6. Hotpot Rice at food stall in Temple Street
7. Jade stall in Wanchai Street Market
8. Flier on lamppost in Clearwater Bay
9. Khalil Fong at Wonderland Restaurant, Tsim Sha Tsui
10. Apartment blocks in Fotan

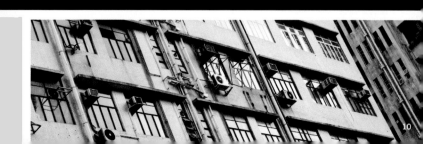

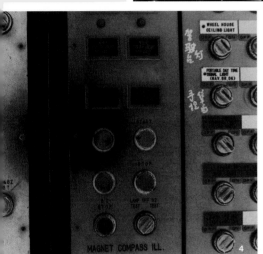

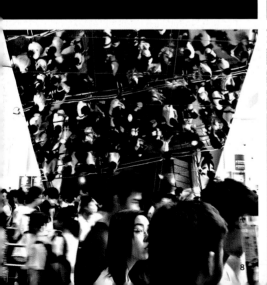

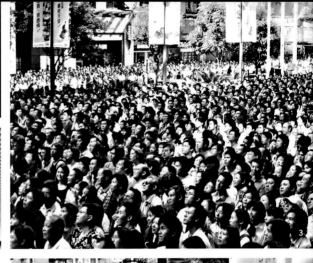

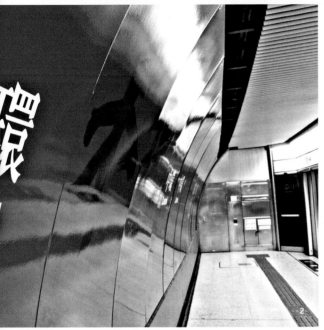

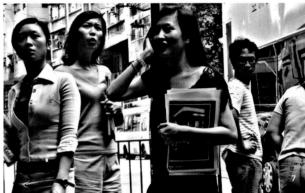

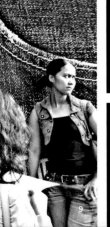

Albert Wen
Wanchai 灣仔
Traveler and occasional
snapshot photographer
www.albertwen.com

1. Tram, Hennessy Road, Wanchai
2. MTR, Central Station
3. Crowds in Times Square
4. Ship control panel, Maritime Museum
5. Queen's Road East at Hennessy Road
6. Landale Street, Wanchai
7. Pedestrians on Hennessy Road, Wanchai
8. Visitors at ACGHK Animation-Comic-Game Hong Kong
9. Great George Street, Causeway Bay
10. H&M, Queen's Road Central

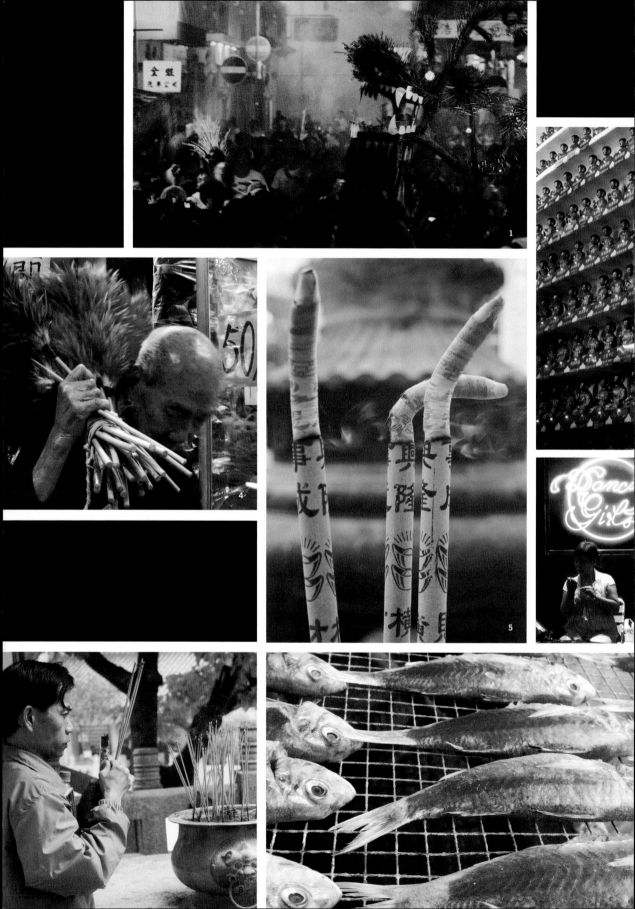

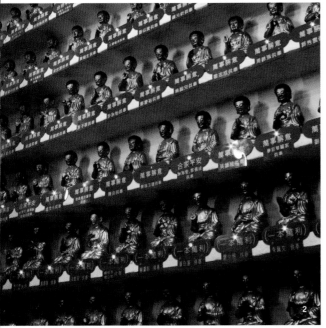

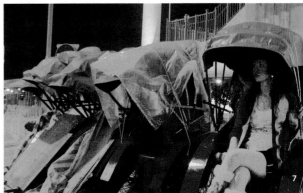

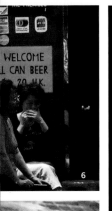

Blair Dunton
SOHO 蘇豪
English teacher
www.blairdunton.com

1. Fire Dragon in Tai Hang
2. 1000s of Buddhas in the 10,000 Buddha Temple, Shatin
3. Snake King in Sheung Wan
4. Feather Dusters in Causeway Bay
5. Joss Sticks at Wong Tai Sin Temple
6. Touts in Wan Chai
7. Rickshaws in Central
8. Prayers at Wong Tai Sin Temple
9. Drying fish in Cheung Chau
10. Lanterns at the Hong Kong History Museum, Tsim Sha Tsui

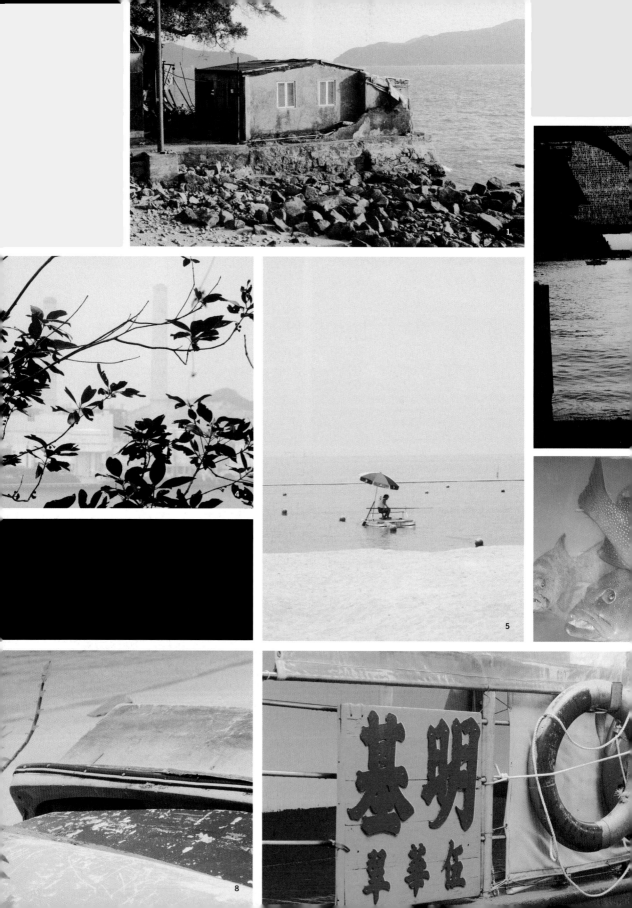

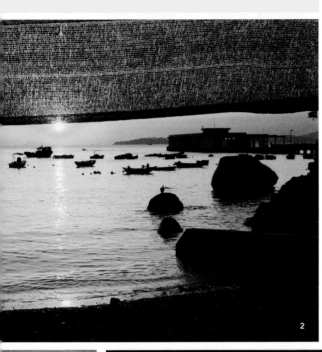

Elizabeth Briel
Lamma Island 南丫島
Artist and photographer
www.elizabethbriel.com

1. Little hobbit-sized cottage in Peng Chau
2. Green Cottage Cafe in Yung Shue Wan
3. Poem written on door on Park Island (the old part of the island)
4. Power Station Beach (some might well call it "poser station beach")
5. Hung Shing Yeh Beach (typically accessed via Yung Shue Wan)
6. Seafood restaurants at Sok Kwu Wan
7. Kid playing with steam vents on Park Island
8. Lo So Shing, Lamma Island's best – but quietest – beach
9. Boat docked at Po Toi Island
10. Dried fish in Sok Kwu Wan, Lamma Island (famous for its seafood restaurants)

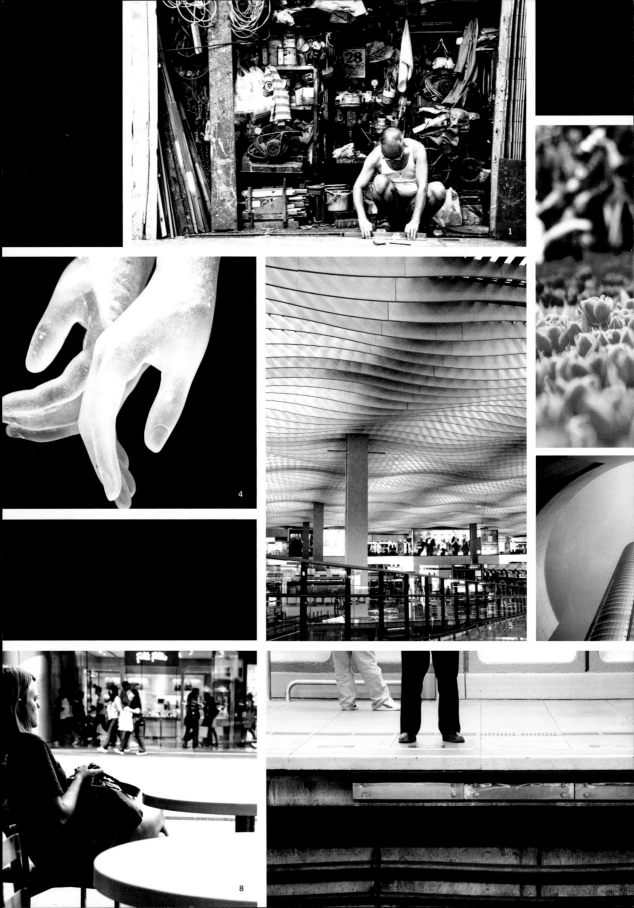

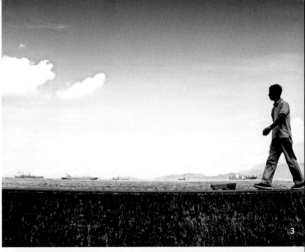

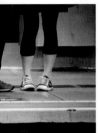

Li Sui Pong "Kit"
Pok Fu Lam 薄扶林
Student
kitracing.deviantart.com/gallery/

1. Workshop in Sheung Wan
2. Hong Kong Flower Show
3. A man at Sandy Bay
4. Mannequin at Skyplaza
5. Skyplaza, Hong Kong International Airport
6. ifc
7. Lamma Island
8. Shopper taking a break at ifc
9. MTR, Kwai Fong Station
10. Cat, Lamma Island

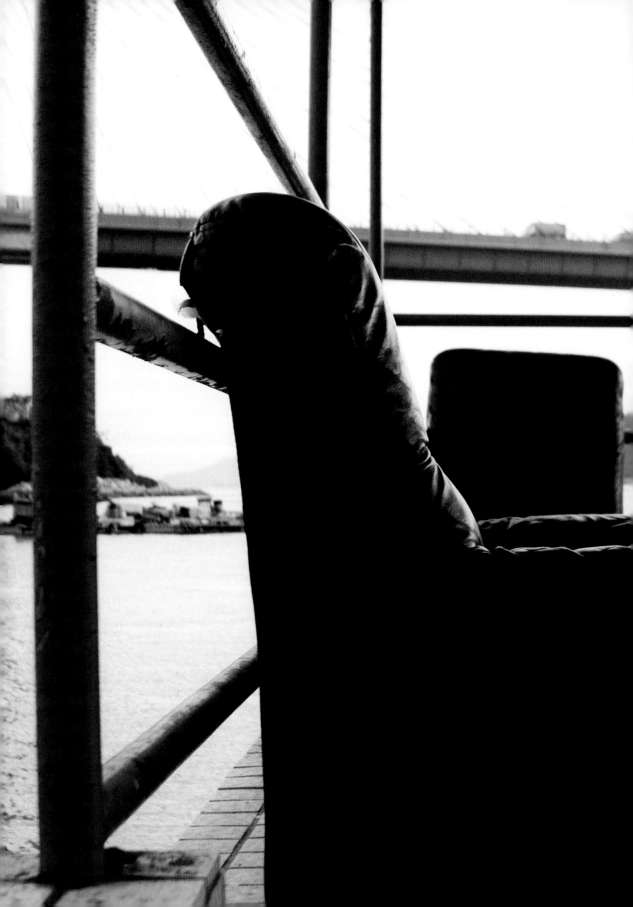

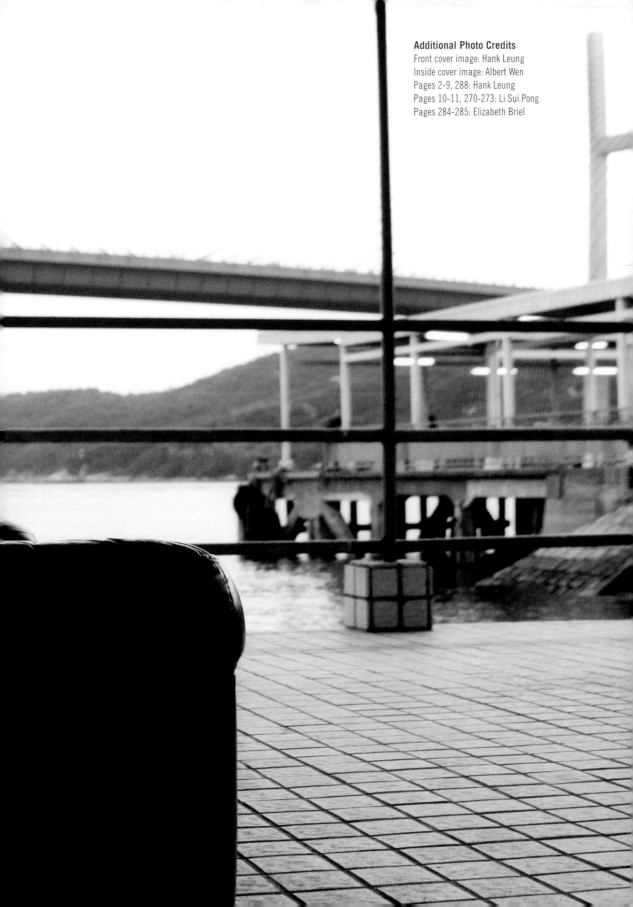

ThingsAsian Press Titles

Exploring Hong Kong
A Visitor's Guide to Hong Kong Island,
Kowloon, and the New Territories
By Steven K. Bailey
Photographs by Jill C. Witt

H is for Hong Kong
A Primer in Pictures
By Tricia Morrissey;
Illustrations by Elizabeth Briel
An English-Chinese Bilingual Book

Strolling in Macau
A Visitor's Guide to Macau, Taipa, & Coloane
By Steven K. Bailey
Photography by Jill C. Witt

Tone Deaf in Bangkok
And Other Places
By Janet Brown
Photographs by Nana Chen

To Myanmar With Love
A Travel Guide for the Connoisseur
Edited & with contributions by Morgan Edwardson
Photographs by Steve Goodman

To Japan With Love
A Travel Guide for the Connoisseur
Edited & with contributions by Celeste Heiter
Photographs by Robert George

To Vietnam With Love
A Travel Guide for the Connoisseur
Edited & with contributions by Kim Fay
Photographs by Julie Fay Ashborn

Everyday Life
Through Chinese Peasant Art
By Tricia Morrissey and Ding Sang Mak
An English-Chinese Bilingual Book

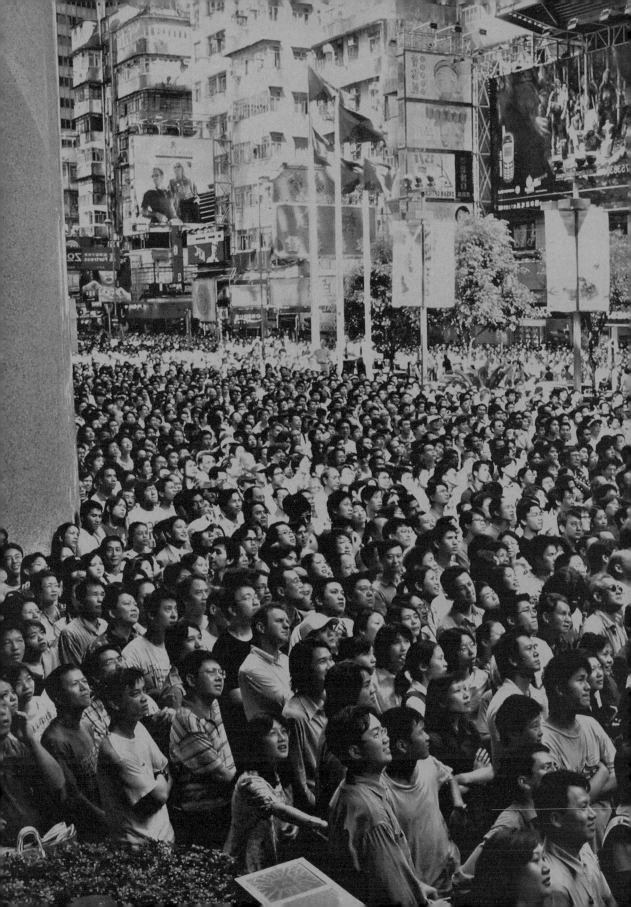